The Campus History Series

LAMBUTH
UNIVERSITY

PAM DENNIS AND SUSAN KUPISCH

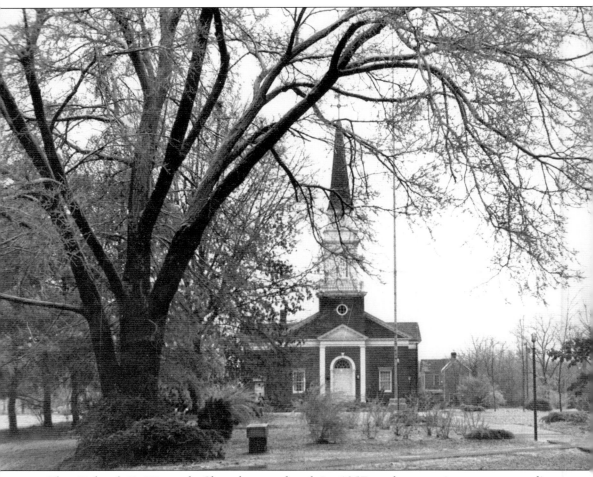

The Richard E. Womack Chapel, completed in 1957 and occupying a commanding position at the center of the quadrangle, emphasizes the centrality of religion in the life of Lambuth University.

We dedicate this volume to the alumni, students, faculty, and staff, whose memories are pictured within these pages.

"Whatsoever things are true, whatsoever things are honest, whatsoever things are just, whatsoever things are pure, whatsoever things are lovely, whatsoever things are of good report: if there be any virtue, and if there be any praise, think on these things." (Philippians 4:8)

The Campus History Series

LAMBUTH
UNIVERSITY

PAM DENNIS AND SUSAN KUPISCH

ARCADIA

Published by Arcadia Publishing
Charleston SC, Chicago IL, Portsmouth NH, San Francisco CA

Printed in Great Britain

Library of Congress Catalog Card Number: 2004106737

For all general information contact Arcadia Publishing at:
Telephone 843-853-2070
Fax 843-853-0044
E-mail sales@arcadiapublishing.com
For customer service and orders:
Toll-Free 1-888-313-2665

Visit us on the internet at http://www.arcadiapublishing.com

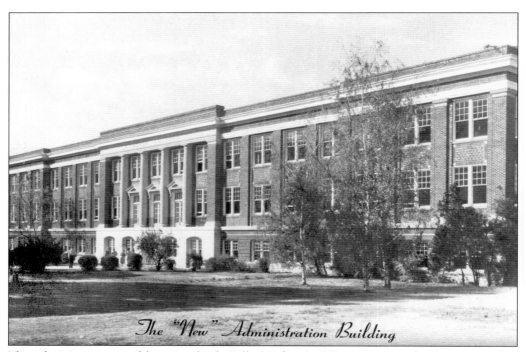

The "New" Administration Building

The Administration Building, Lambuth College's first building, was completely renovated in 1953 as the first phase in a major building program that resulted in the beautiful campus of the present Lambuth University.

CONTENTS

ACKNOWLEDGMENTS

Images were gathered from the university's archives, including yearbook pictures and loose photographs. Information was gleaned from student newspapers, school catalogs, and other publications, and from Sarah Clement's book, *A College Grows . . . MCFI-Lambuth* (Lambuth College Alumni Association, 1972). We would like to thank the Memphis Conference for its financial contribution to the archives and Ann Phillips, Mary Willett, and Jackie Wood for their long hours of service in maintaining the collection. Special thanks to Lisa Billingsley for processing preliminary notes and to Susan Banks for scanning rare photographs.

We particularly thank the editorial staffs of the school's newspapers and yearbooks, for without their hard work, there would be no record of the day-to-day activities that were shared by those who attended this institution. We also wish to thank the editorial and production staff of Arcadia Publishing, whose expertise polished the final result.

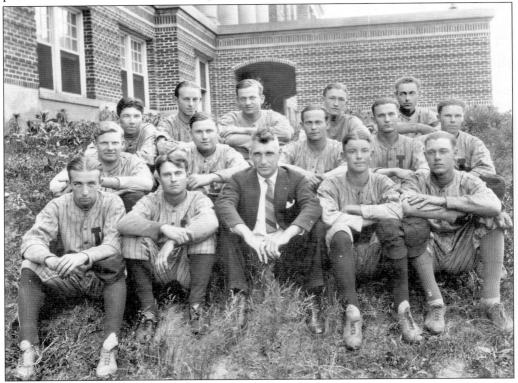

Marvin E. Eagle served on the first faculty at Lambuth College. Holding degrees from Kentucky Wesleyan and Vanderbilt, he served as history professor, athletic director, head coach (football, baseball, tennis, and golf), and academic dean. The Lambuth "Eagles" were named in his honor. Eagle is shown here with the 1937 baseball team.

INTRODUCTION

Memphis Conference Female Institute (MCFI) was chartered on December 2, 1843. Lorenzo Lea was elected the first president and served until 1853. The school was described as having a "large brick building with a smoke house and kitchen about sixty feet away from the main building. . . . the dormitory was equipped with mahogany sofas, mahogany bedsteads, chairs, pianos, and one thousand and ninety pounds of feathers."

A.W. Jones assumed the presidency in 1853 and served until 1878. As was typical of small institutions of learning at the time, the president and his family owned the school and served as its faculty members and administrative officers. During Jones's term of office, Jackson was occupied by the Union Army and MCFI was turned into a Federal hospital, but Jones was not to be stopped. He moved the campus to his home at 365 South Royal and continued classes until the campus was restored to the institute in 1863.

Jones retired in 1878, and his son, Amos Blanche Jones, served as president until 1880. After his son became president of Huntsville Female Institute, A.W. Jones returned to the presidency at MCFI and served until his death in 1892. His wife served as president until a new president was secured.

Dr. Howard W. Key became president in 1893. A dome was added to the building, a fully equipped gymnasium was built, and equipment was bought for a bowling alley. Tennis, croquet, and, by 1908, basketball were favorite outdoor activities. Degrees included the mistress of English literature, artium baccalaureus, artium magistra, mistress of science, and mistress of letters.

Dr. Key stepped down in 1897, and A.B. Jones again became president until 1911. Towers were added to the building, and the kindergarten program was discontinued.

Three men served as president during the turbulent 1910s: Rev. Dr. S.A. Steele (1911–1913), Rev. H.G. Hawkins (1913–1917), and Rev. R.E. Naylor (1917–1920). There was a move to create a Grade A women's college, but by 1919 it was determined that the MCFI property would not support a major building program.

Under the leadership of Dr. J.W. Blackard (acting president, 1920–1924), an amendment was made to the MCFI charter, the campus was moved to a new location, and Lambuth College was born on May 12, 1924. A co-educational institution, the school was named for Methodist missionary Bishop Walter Russell Lambuth. Dr. Richard E. Womack became the president and served for the next 28 years. During its first three years, Lambuth was awarded membership in the Southern Association of Colleges and Schools and the Tennessee College Association. Dr. Womack celebrated the construction of Lambuth's first two buildings—Administration Building and Epworth Hall. The sports program began under the leadership of Coach Marvin Eagle and included baseball, men's and women's basketball, football, and hiking. Golf and tennis were later incorporated into the program. Ground was broken in 1947 for a physical education building. That same year the Federal Works Agency gave the campus a two-story barracks to house the bookstore, student union, and music department. In 1949 a physical science building was completed and the Little Theater was established.

Lambuth saw its greatest growth under the presidency of Dr. Luther L. Gobbel. He transformed the small campus into the present facility. Ground was broken on January 20, 1953, for Sprague Hall (women's dorm); the Chapel–Fine Arts Building (now Womack

Chapel) was dedicated on April 29–30, 1957; R.E. Womack Physical Education Building (now HPAC) was dedicated in 1959; and the Administration Building was renamed and dedicated on November 14, 1960. The building program continued with the dedication of Harris Hall (men's dorm), Williamson Dining Hall, and the Luther L. Gobbel Library on February 3, 1962.

James S. Wilder Jr. became president in 1962. During his tenure, the rest of the campus was completed, including the Wilder Student Union (1966), Joe Reeves Hyde Science Hall (1967), Carney-Johnston Hall (1967), Athletic Center (1969), L.L. Fonville Field (1969), the renovation of Womack Physical Education Building to house fine arts (1971), and the planetarium (1973).

On June 1, 1980, Dr. Harry W. Gilmer became president. He brought football back to Lambuth in the fall of 1985 after a 40-year lull. This helped increase the male population of the school to more equally match that of the females. There was also an increase in international student enrollment during his tenure.

Gilmer was followed by Dr. Thomas F. Boyd as president in July 1987. Under Boyd's leadership, the school attained university status. The Jane Hyde Scott Center for Christian Studies was created in 1990, and the Oxford overseas study program was begun in 1994. While Boyd was president, the Senior Commons Soccer Complex and Pope Commons were built. Enrollment increased.

W. Ellis Arnold III became president on January 1, 1997. Under Arnold's leadership, alumni support increased to record levels. The university's landmark building was dedicated on December 2, 1998, as Varnell-Jones Hall. Oxley Square and its four buildings—Whetstone House, Loeb House, Henley House, and Dawson House—were dedicated in 1999, and the Lambuth Theatre was completely renovated and dedicated as the Hamilton Performing Arts Center (HPAC), on March 25, 2000. A strategic plan for the future (Lambuth Vision 2010) was approved by the Lambuth Board of Trustees, along with a 20-year campus master plan. The university has gained national recognition by *U.S. News & World Report* as one of the South's best educational values and by the education editor of the *Washington Post*, who listed Lambuth as one of the nation's "Top 100" colleges that deserve recognition.

Throughout these 160 years, Lambuth has been dedicated to providing the highest quality, church-related, liberal arts education to its students. In turn, these students have contributed to the betterment of every aspect of our society. May students and friends always be loyal to Lambuth and continue to "raise the lamp, the white and blue, for whatever things are true."

One

MEMPHIS CONFERENCE FEMALE INSTITUTE

1843–1920

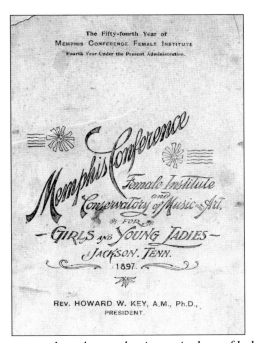

The artium magistra degree was based on a classic curriculum of belles lettres (humanities, including literature and creative writing), mathematics, natural sciences, languages, music, and art.

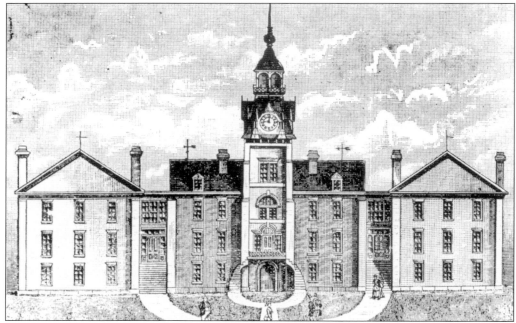

Memphis Conference Female Institute (MCFI) began in 1843 as an educational institution for young women, under the auspices of the Memphis Conference of the Methodist Episcopal Church, South. The original property was owned by William E. Butler, the "Father of Jackson," and was formerly the location of a horse racetrack frequented by President Andrew Jackson. An architect's rendering shows a proposed building with a clock tower and two wings.

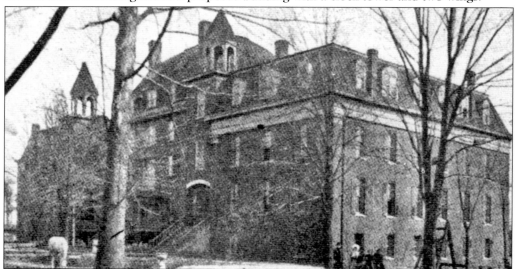

The only structure on the MCFI campus was a four-story brick building that housed the president's office, parlors, family departments, kitchens, washrooms, clothes rooms, storerooms, pantry, and 17 boarding rooms. The west wing included the chapel, music department, art department, and reading room, which was connected to the library. Rooms were equipped "with mahogany sofas, mahogany bedsteads, chairs, pianos, and one thousand and ninety pounds of feathers."

MCFI's first president was Lorenzo Lea, who served from 1843 to 1853. Born January 4, 1806, he also taught in North Carolina and Mississippi. He died at Corinth, Mississippi, on October 7, 1876. A.W. Jones, shown here, served MCFI as president from 1853 to 1878. A graduate of Randolph-Macon College in Virginia, he and his family owned the school and served as its faculty members and administrative officers.

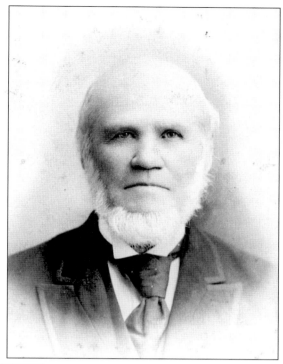

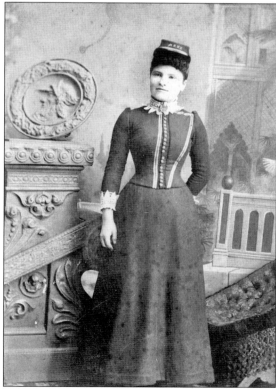

Students were required to wear uniforms. In 1869–1870 royal purple was worn in winter, pea green in spring and fall, and white in summer. A plain straw hat trimmed in black velvet was worn in winter, the ribbon being exchanged for pink in summer. By 1880 the winter uniform was changed to blue wool with an "institute hat." Miss Ella Turner poses in her uniform in 1890.

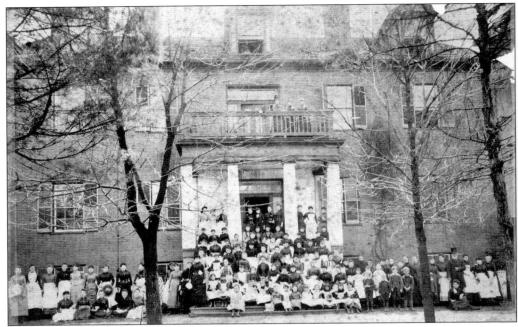

The entire school body posed for this picture in 1886. Note the little boys who were studying at MCFI in the early years.

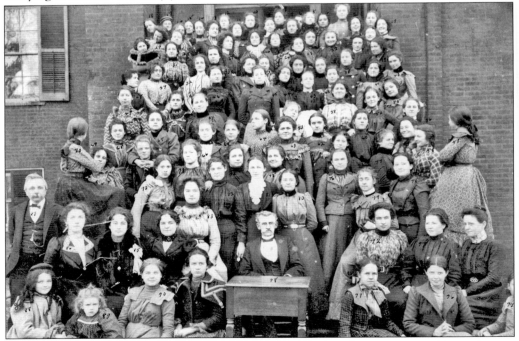

Amos Blanche Jones, son of A.W. Jones, served as president from 1878 to 1880 and again from 1897 to 1911. He is shown in the center of this photograph of the entire student body in 1900. The photograph also includes Erwin Schneider, one of many German professors who served as head of the music department.

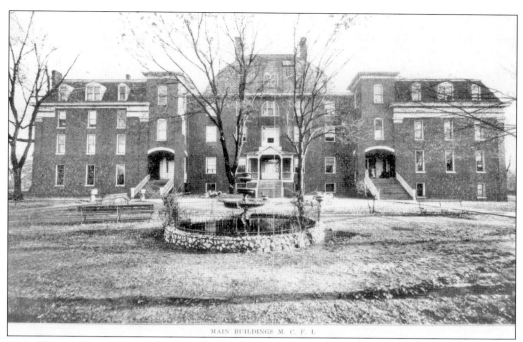

MAIN BUILDINGS M. C. F. I.

An additional wing was added to the building in 1885 that included a dining hall and 12 more boarding rooms.

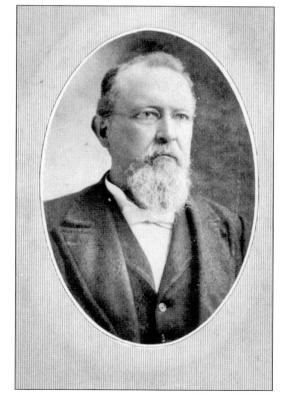

The school celebrated its 50th anniversary with the hiring of Emory University graduate Howard W. Key as president. The school's name was officially changed to Memphis Conference Female Institute and Conservatory of Music and Art for Girls and Young Ladies. Key served until 1897.

Although it was well known for its classical education and music conservatory in the early days, by World War I MCFI boasted an industrial department that provided skills for women who wished to become part of the town's work force. The commercial department included courses in typewriting, bookkeeping, and stenography. Shown are Lucille Lashlee, Helen Ridgeway, Cordia Parimore, Sallie Jane Fry, Peggy Campbell, and Geneva Rast.

Another area of study at MCFI was the Department of Elocution and Physical Culture. Students were drilled in recitation and trained in articulation, vocalization, and tone production. At the end of the term, students were expected to perform in recitals, recitations, and plays that were open to the public.

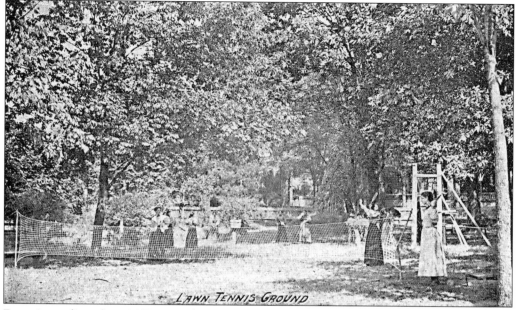

LAWN TENNIS GROUND

From its earliest days, MCFI's students were encouraged to participate in daily walking and calisthenics. In 1893 a fully equipped gymnasium was built and equipment was bought for a bowling alley. By 1898 tennis, croquet, and basketball were favorite outdoor activities.

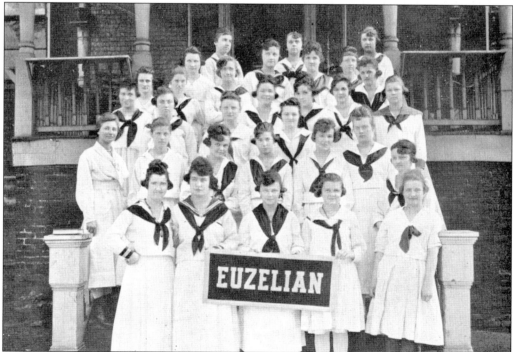

EUZELIAN

The Euzelian Literary Society, one of two literary circles, was one of many societies enjoyed by the ladies of MCFI. Membership requirements included having perfect attendance, maintaining 90 or above in deportment, and being on the honor roll.

Shown here is a program from a Euzelian Society recital in 1881.

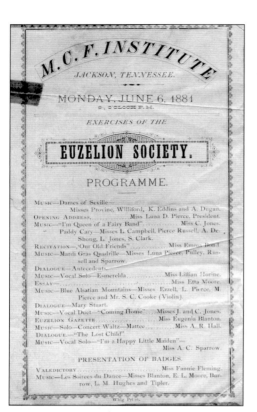

Courses were offered in all areas of music and included piano, organ, violin, voice, guitar, mandolin, zither, and orchestral instruments. A program from 1915 lists a variety of pieces performed at the annual recital.

16

Members of the junior class in 1919 included, from left to right, Eurie Wilford, Sonya Downs, Charline Rich, Nadine Crawford, Portia Hamilton, and Martha Bowe.

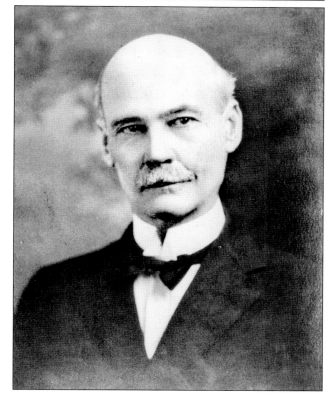

The last presidents of MCFI were Rev. Dr. S.A. Steele (1911–1913), Rev. H.G. Hawkins (1913–1917), and Rev. R.E. Naylor (1917–1920). Dr. James William Blackard, shown here, served the school during the transition time between the closing of the female institute and the opening of the new college. An active minister in the Methodist Church throughout West Tennessee, Blackard raised money for the new campus and provided continuity between the two institutions.

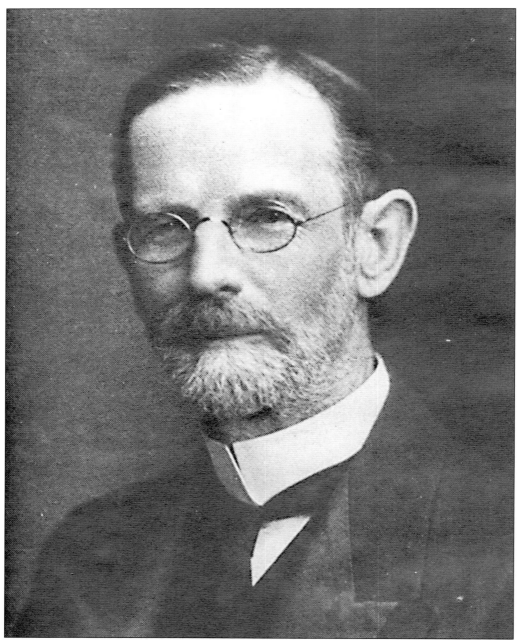

The new school was named for Walter Russell Lambuth, born in Shanghai, China, of missionary parents. A graduate of Emory and Henry College and Vanderbilt University, he was ordained by the Tennessee Conference of the Methodist Church and returned to China to serve as a medical missionary. Elected as bishop of the Methodist Episcopal Church, South, in 1910, Lambuth was assigned to Brazil and later established Southern Methodism in the Belgian Congo, Belgium, Poland, Czechoslovakia, and Siberia until his death in 1921.

Two
LAMBUTH COLLEGE EMERGES
1920s–1930s

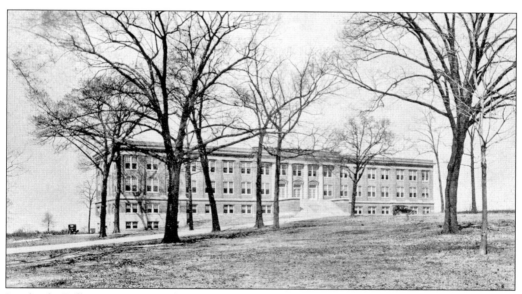

Lambuth College was opened on September 10, 1924. The Administration Building had three floors, a partial basement, and cost $130,000 when built in 1923. The basement housed the furnace room, men's toilet, shower baths, and chemistry and physics laboratories. The kitchen, dining room, matron's office, practice rooms, library, chapel, biology laboratories, and classrooms were on the first (ground level) floor. The president's office, matron's apartment, reception room, assembly room, two classrooms, and a few student bedrooms were located on the second (main) floor. The third floor served as the women's dormitory and had a capacity for approximately 100 women.

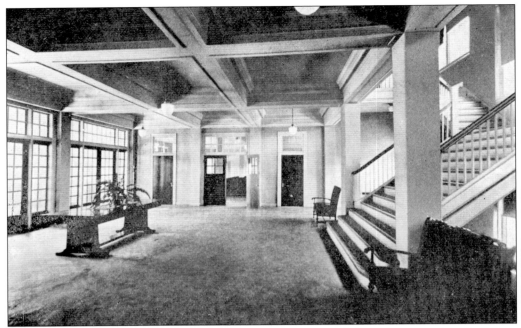

The main floor lobby was located on the second floor of the Administration Building. The doors at the end of the hall led to the auditorium, where opera seats provided comfortable seating.

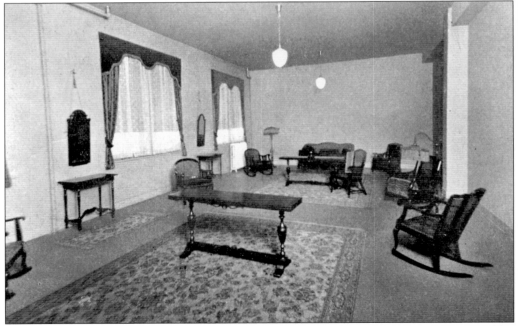

The parlor was located on the second floor of the Administration Building and was used for visitation and entertaining purposes. It is shown here with period furniture and decor.

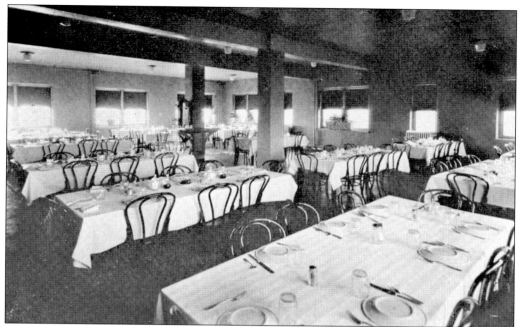

The dining room was built with aid from summer school students who excavated the south end of the Administration Building and constructed the basement. The room accommodated approximately 175 people. It was operated primarily for women living in the dormitory. The cost for table board was $20 per month of 28 days. Male students and some faculty also ate meals in the dining room.

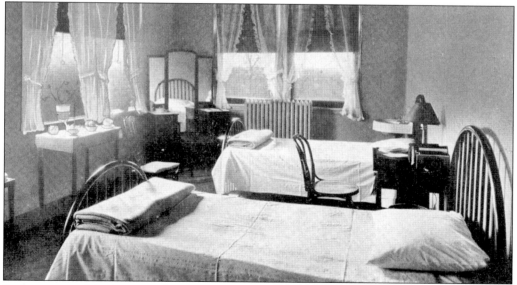

Bedrooms and bathrooms for female students were located on the third floor of the Administration Building. Lodging cost $10 per month. Each bedroom was furnished with steel furniture in American walnut finish, including a vanity dresser and bench, two study desks, two beds, two bentwood chairs, two rugs, and linens. Male students resided in furnished rooms in the neighborhood during these early years.

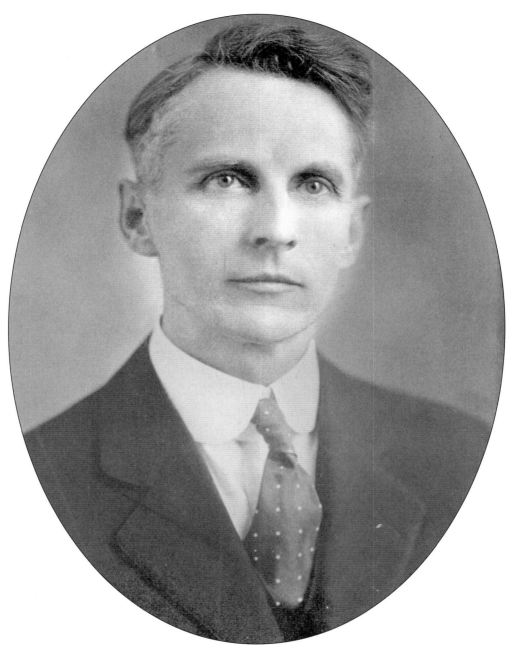

Dr. Richard Elwood Womack, Lambuth College's first president, was born in Centerton, Arkansas, on November 4, 1882. He received his bachelor's degree from the University of Arkansas and an artium magistra degree from George Peabody College in Nashville. He was later awarded an honorary LL.D. from Union University. Before coming to Lambuth, he served as head of the history department at Arkansas State Normal School (1907–1917), summer faculty at Peabody College (1915), superintendent of public schools in Conway, Arkansas (1917–1922), and headmaster at Hendrix Academy in Conway (1922–1924). His term of office at Lambuth was from 1924 to 1952.

THE FIRST FACULTY

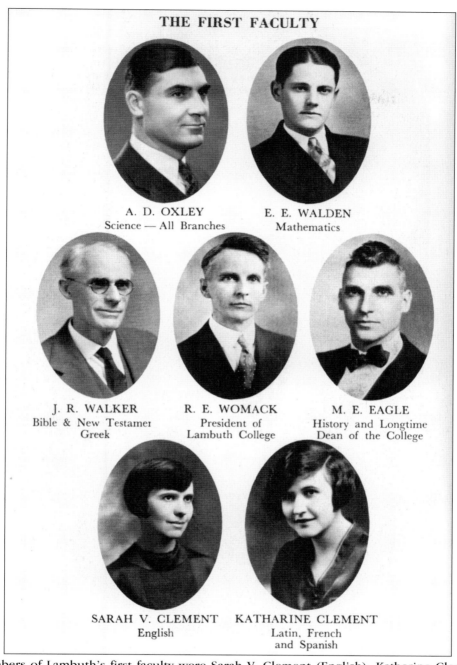

A. D. OXLEY
Science — All Branches

E. E. WALDEN
Mathematics

J. R. WALKER
Bible & New Testamen
Greek

R. E. WOMACK
President of
Lambuth College

M. E. EAGLE
History and Longtime
Dean of the College

SARAH V. CLEMENT
English

KATHARINE CLEMENT
Latin, French
and Spanish

Members of Lambuth's first faculty were Sarah V. Clement (English); Katherine Clement (languages); Marvin Edward Eagle (history and physical education); Arthur D. Oxley (biology); Emory Earl Walden (mathematics); J.R. Walker (religion); and Louise Mercer (director of fine arts). Other faculty added within the first three years included Robert Deese Jr. (chemistry and physics); Charles O. Moore (education, social sciences, football, and baseball); Mamie Lucille Womack (physical education); and Arthur A. Seeger (voice and violin).

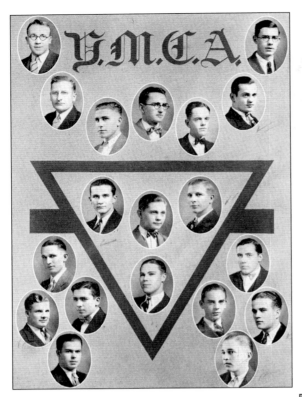

The YMCA was one of the first student organizations at Lambuth. Weekly meetings focused on developing the religious life of the college's men. Other early organizations were the Mouzon Literary Society (men), named for Bishop Mouzon; the Euzelian Literary Society (women), named for its MCFI equivalent; and the Life Service Band.

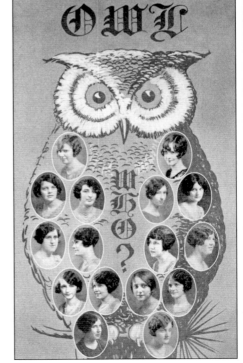

The O.W.L. Club, organized in 1926, was one of the first social clubs for women. Their motto was "a deep, dark secret," and their colors were black and gold.

In 1928 chapel was held four times a week in the auditorium located in the Administration Building. All students were required to attend. The "exercises" were presented by faculty members, area ministers, and sometimes students. Students were also expected to attend Sunday school and church services each week. The religious education department was under the leadership of Rev. J.R. Walker.

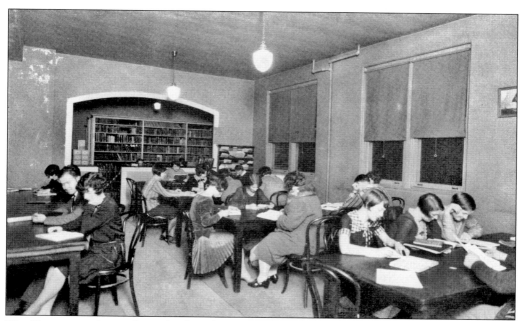

The library was located on the first floor of the Administration Building in the 1920s and housed reference books and special subject references. There were 25 weekly and monthly periodicals available in the reading room. The library also housed a "Little Ben" clock. A brass dinner bell that signaled the changing of classes was rung in the lobby and could be heard throughout the building.

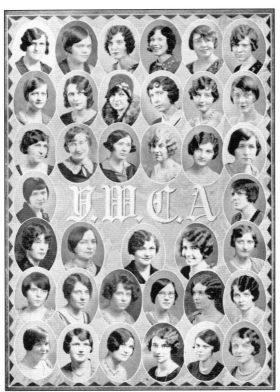

The YWCA was initiated in 1926 and focused on the religious life of women at the college. Cabinet members were Dorothy Grimes, Katherine Maxwell, Frances Covington, Leora Bledsoe, Frances Reid, Margaret Martin, Sara Margaret Rose, Mary Agnes Oliver, Wilma Cherry, and Anna Belle Samples. In March of 1929 the members of the YWCA created a tearoom called The Secret and served sandwiches, salads, and drinks.

Athletic competition was part of Lambuth College from its beginning. In 1924 there were teams in football, men's basketball, women's basketball, and baseball. Intramural tennis, ground ball, and hiking were also available. Lambuth was a charter member of the Mississippi Valley Conference in 1927. The first football team ended the year with a winning season of 5-2. Coach Marvin Eagle is shown below with the earliest football players.

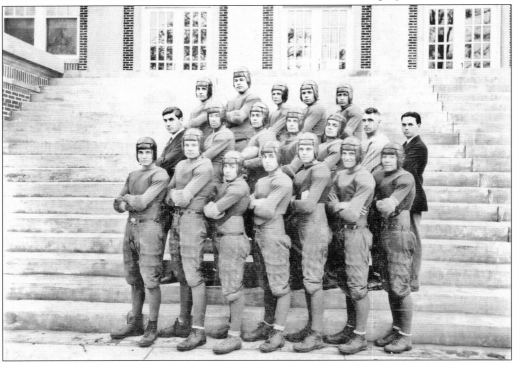

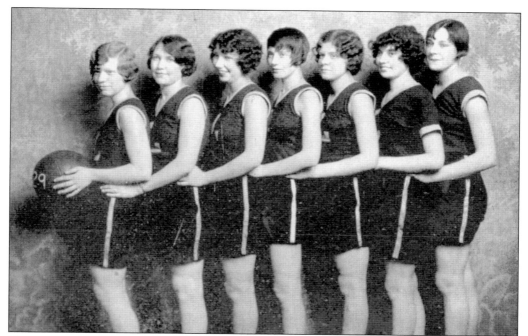

The women's basketball team started in 1924 and was under the leadership of Coach Lucille Womack. In 1929 the women's basketball team presented letters to Sarah Gray, Coby Threadgill, Erda McClanahan, Abie Samples, Pauline Harris, Rita Pontius, and Lucille Jones. They won consecutive conference titles in 1934 and 1935, with four of the players making the All-Star Conference team. Miss Harris, guard, was named conference Most Valuable Player in 1935.

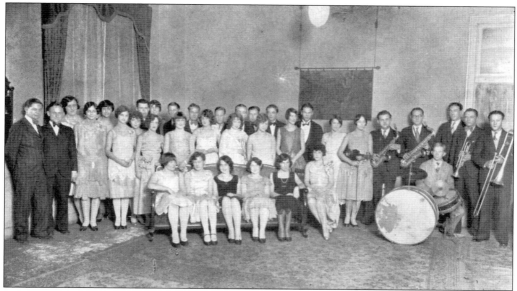

The fine arts club (1929) was composed of orchestra, glee club, and dramatic club members. Under the direction of Katherine Clement and Arthur Seeger, the club focused on the performing arts and met on the second and fourth Tuesday nights of each month.

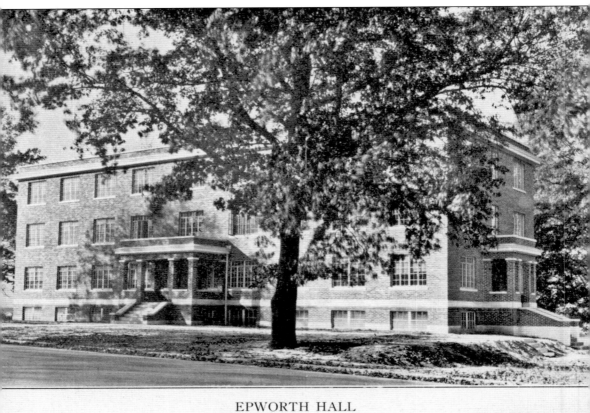

EPWORTH HALL

Epworth Hall was completed in 1929 as a new dormitory for boys. It was built by the Epworth Leaguers of the Memphis Conference. The hall housed young men attending the Epworth League Assembly during the summer and Lambuth male students during school terms. In 1931 new club rooms were furnished in the men's dorm for Theta Psi, Sigma Alpha, and Kappa Phi Epsilon. By 1935 there was a recreation room in the basement with chairs, davenports, lamps, tables, a piano, and a battleship-grey painted floor. The building was completely redecorated in 1953 and again in 1960, later serving as the offices of Chancellor Wilder and finally as the home for the Memphis Conference until 2001.

Lambuth Beloved----Alma Mater

Hail to Lambuth, our Lambuth beloved,
 School of ideals, of sunlight, and song;
Tho' afar from thy campus removed,
 Still our hearts shall for thee ever long.

Chorus
Sweet thy memories, thy fond recollections,
 'Tis the dear school that gave us our worth;
How you hold, college dear, our affections,
 Alma Mater, the fairest on earth!

May our colors, the white and blue streaming,
 Our emblems of love and of truth,
Be as sunlight upon our path beaming,
 Dear in age as they now are in youth.

O Lambuth, where'er life may lead us,
 In sorrow, or sunshine, or joy,
Thy motto shall still be our watchword,
 Thy praises our tongues shall employ.

The first alma mater, "Lambuth Beloved," was written in 1927 by Mrs. Charles Moore and was based on "Italia Beloved." Written for a dinner party, it was never intended to be the alma mater. A new alma mater, written by Hollis Liggett to a tune by Prof. Elizabeth Fossey, was printed in the 1952 yearbook. The current alma mater was written by Richard Brown and his daughter Cynthia in 1986.

The first class graduated from Lambuth College in 1927 and included T. Erle Hillard, C.N. Jolley, Lois Laman, Constance Morelock, Glendell W. Pafford, Valdora Seissinger, Anne Warden, and Elma Lee Womack. The Jackson Lambuth Club was the first alumni association of the College. This picture represents a few of its members and includes Wilma Cherry (president), Elizabeth Hicks (vice president), and Frances Reid (secretary/treasurer), shown here directly above the club title.

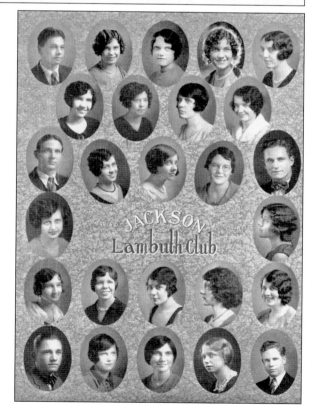

29

Lambuth Ministerial Brotherhood, established in 1928, represented the ministerial students of the college. Its purpose was to cultivate fellowship and to study topics of interest to its members. A later organization, the Christian Movement Council, directed and coordinated religious activities on campus and served as an umbrella council for other organizations in fostering community outreach and church relations.

D.D.D.D. was founded at Lambuth in 1924 and was listed as the first women's social club. Its colors were red and black, and the red rose was its flower. It became Tau Delta Sorority in 1927. The founders for Tau Delta were Valdora Seissinger, Alice Welch, Johnnye Hilliard, and Pattie Sue Hurdle. Its first annual convention was held in May 1932.

Omicron Phi Tau was founded at Lambuth College in 1930 as the first honorary society. Jack Kent was the founder and Leora Bledsoe the first president. Members included Pansy May Gowan, Rubye Jackson, Wilma Stanley, Jewell Reed, Mary Louise Brooks, Charles Stanfill, W.S. Evans, Chester Parham, Sara Spangler, and Sarah V. Clement (honorary).

Omega Upsilon Lambda Sorority was founded in 1926 with black and gold colors. The flower was the moonflower (later changed to talisman rose), and its emblem was an owl. Sarah V. Clement was the sponsor. The sorority was known for its annual moonlight picnics. In May 1932 the students "motored" up to Humboldt Country Club, where they enjoyed a great evening of socializing.

Sigma Alpha Fraternity was the first fraternity at Lambuth. It was founded in 1927 with blue and gold colors (standing for friendliness and honesty) and the red rambler rose as the flower. Its founders were Allan Ferguson, Charles Sparks, Harold Stanley, Comer Hastings, Charles Ross, and Paul Robinson.

Theta Psi Fraternity was formed in April 1930 with blue and maroon colors, the white carnation for the flower, and a motto of loyalty, courage, ambition, and, above all, brotherhood. Its founders were Ed Terry, Orval Weir, Haywood Smith, Edwin Diggs, William Barnes, Manley Wadsworth, Rhesa Davis, Elton Winslow, Luther Nabors, Vernon Bradley, Wilber Harrington, and Coleman Smith. Known for its lavish coronation balls, the fraternity affiliated with national fraternity Delta Sigma Phi on April 10, 1959.

Beta Sigma Alpha was founded in 1929 with black and white colors, a white rose for its flower, and an elephant as its emblem. Founding members included Wilma Cherry, Elizabeth Douglass, Abie Samples, Bernice Fant, Cornelia Lassiter, Lacy Lassiter, Lucille Bessent, and Kathryn Hopper. The sponsor was Mrs. Rawl.

Kappa Phi Epsilon was founded at Lambuth in 1930 with black and orange colors, the snapdragon as the flower, and the Chinese dragon as its symbol. The founders were Burl Smith, Lowell Council, J. Doyne Young, Aaron Walker, Butler O'Hara, Chester Parham, and J.S. Scott.

The Eagles men's basketball team won the conference championship for the second consecutive year in 1935 and was invited to participate in the National A.A.U. tournament in Denver.

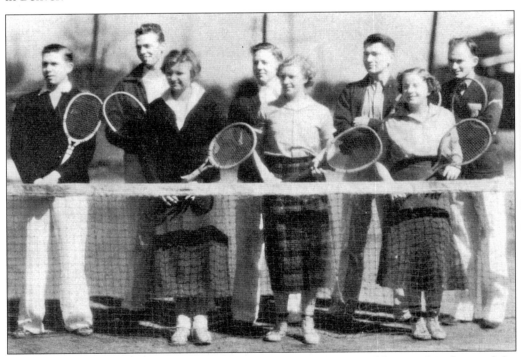

The tennis court was well placed behind the Administration Building and in front of the athletic field on the 25-acre campus. Coach Eagle declared a half-day holiday in 1924 so faculty and students could pull up cotton stalks behind the Administration Building. The three-hour chore cleared space for tennis and baseball facilities and ended with a bonfire and picnic. Lambuth tennis teams won the Mississippi Valley Conference Championship for eight consecutive years during the 1920s and 1930s.

The Literary Forum was formed in the mid-1920s. Their sponsor was Sarah V. Clement, and Willard Googe was president.

The Womack Debating Club was established in 1934 for the purpose of studying and practicing the fundamentals of debate. Members engaged in intercollegiate contests. These 21 participants shown here were on the 1936 team.

The pep club is shown for the first time in the 1937 *Lantern* with cheerleaders Ennis Robbins and Louis Wrather. The club was active at sporting events, cheering for Lambuth teams.

The first play at Lambuth, *The Arrival of Kitty*, was presented in May 1925 for commencement. Its cast served as charter members of the dramatic club, organized on September 23, 1925, by Katherine Clement. The money raised was used to erect a grandstand for the athletic field and a stage in the auditorium, and to present the football team with blue and white blankets. The dramatic club is shown in 1937 with 25 members.

The judicial committee was established in 1936 as part of the student government new constitution, which embodied executive, judicial, and legislative branches. T.W. Doty served as chief justice and Walter Thomas as student body president.

The Camera Club was organized in 1937 and had 26 charter members. Arthur Oxley was the sponsor, and Warren Garrett was the first president.

Helen Womack is well remembered for her long term as registrar. A graduate of Lambuth in 1929, she served as registrar from 1934 to 1942, taught home economics from 1942 to 1946, served as part-time teacher and registrar from 1946 to 1951, and resumed full-time duties as registrar from 1951 until her retirement in 1954.

The glee club was organized in November 1925, performed twice a month at Hayes Avenue Methodist Church, and sang at the annual conferences. The 40-member glee club is shown here in 1938 in their new robes in preparation for a formal concert. The following year, they performed A.R. Gaul's oratorio, *The Holy City*, at First Methodist Church and the operetta *The Battle of Barcelona* at Jackson High School.

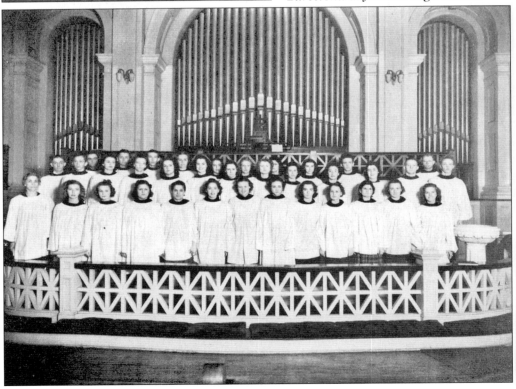

Three

THE COLLEGE GROWS
1940s–1960s

The front steps to the Administration Building created a popular place to socialize on the Lambuth campus. Alums fondly remember the steps and the friendships nurtured there. The Administration Building was renovated in 1953. A handsome limestone front replaced the huge steps leading to the second floor lobby and new porticos were added to each side of the building. All interior space was refurbished and reorganized for modern classrooms, office, library, auditorium, and cafeteria space. Completely new science labs were provided on the third floor.

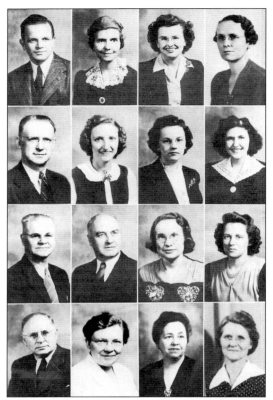

Members of the faculty in 1944, listed from left to right and top to bottom, were S.R. Neel (religion); Sarah V. Clement (English); Mary-Mac Wells (business administration); Ruth Marr (education, psychology, and registrar); Audree Thomas (business manager); Emily Hastings (social science); Rebecca Raulins (chemistry and physics); Katherine Clement (French and librarian); H.L. Palmer (business administration); Arthur Evans (modern languages); Elisabeth Fossey (music); Helen Womack (home economics); Otto Waldner (music); Blanche Evans (education and psychology); Mattie Fletcher (secretary to president); and Mrs. Robert McGowan (dietitian).

The women's dormitory in 1941 was on the third floor of the Administration Building and was a place for socializing and sharing treats from home. Later editorials lament the good old days on the "old third" when everyone knew each other so well.

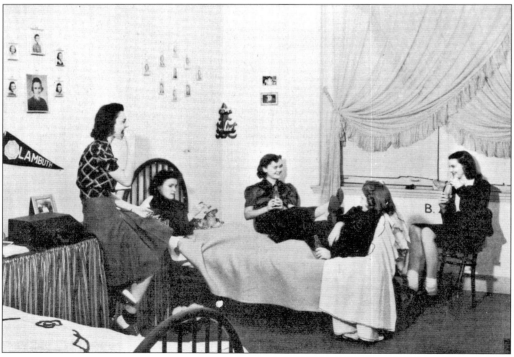

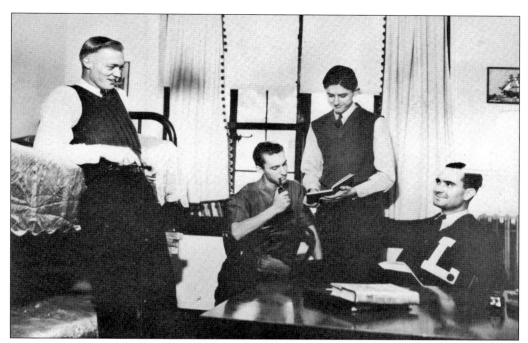

The men's dormitory in 1941 was in Epworth Hall and housed 50 bedrooms. The rooms were spacious with beds, closets, and desks for studying.

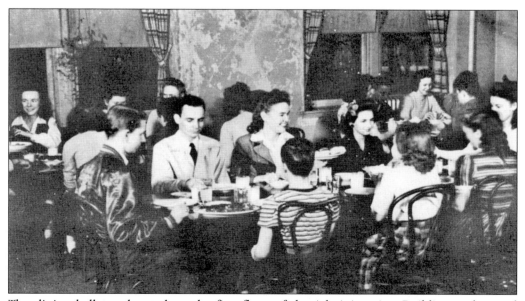

The dining hall was located on the first floor of the Administration Building and served three meals per day and special occasion dinners. Board was $207 for the nine-month school term in 1943–1944.

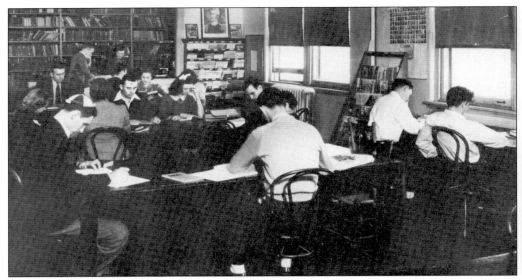

The library in 1941 was located on the second floor of the Administration Building. This picture shows the arrangement of the room, study tables, and college student attire, including a freshman "beanie."

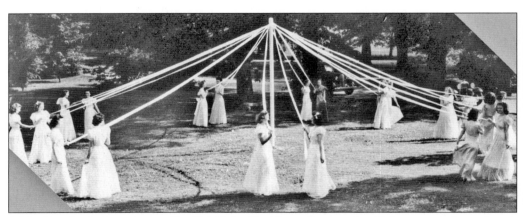

A May Day festival, sponsored by Phi Alpha Mu Home Economics Club, was celebrated each year on the lawn in front of the Administration Building. Friends would come to watch the crowning of the May Queen. The May pole dance, the wreath dance, and the flower drill were all events of the day.

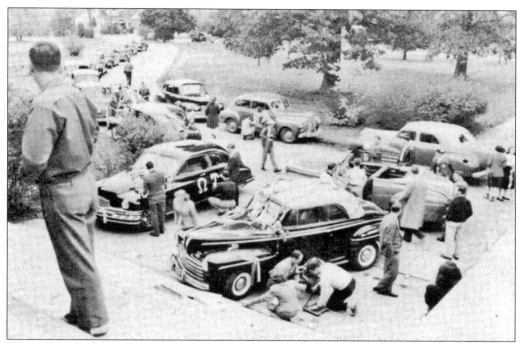

Cars on campus increased in the late 1940s and were a part of coed social life. Car parades became a campus and community event.

Les Treize Jeunes Français was initiated at Lambuth in October 1926 as a chapter of L'Alliance Française des Etas-Unis et du Canada. Formed of 13 advanced students from French III and IV, the club met for conversation and appreciation of the French language. Later called the French Club, the group, under the leadership of Katherine Clement, met weekly to converse and enjoy a program.

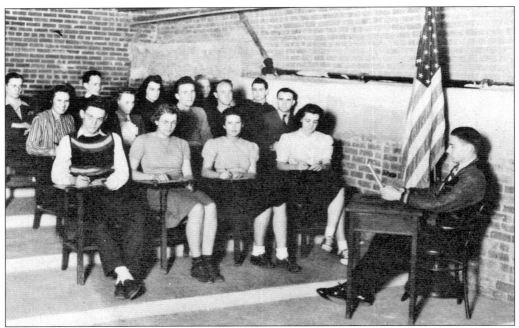

The student council, composed of four representatives from each class and presided over by the student government vice president, was the legislative branch of the student government. A tradition was begun in 1933 featuring "the year's best sellers." In 1940 winners were identified as Beldon Langdon (Most Handsome); Mary Lou Thomas (Most Popular); Webster Kelley (Best All-Around); Coffman Mitchell (Most Popular); Charlotte Fisher (Most Beautiful); and Charles Cosner (Most Intelligent).

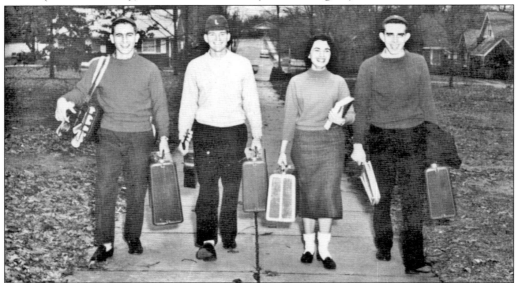

Freshman class officers of 1956–1957 are shown leaving campus after a successful first year. Golf clubs, guitar, tennis rackets, and books accessorized the coeds, along with beanies and Lambuth hats. Shown from left to right are Carl Taylor (vice president); Jimmy Moore (president); Patricia Wiley (secretary); and John Evans (treasurer).

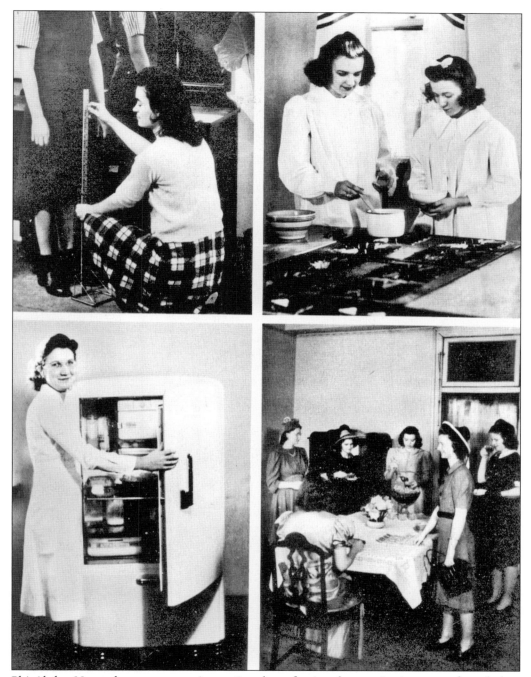

Phi Alpha Mu, a home economics national professional organization, was founded at Lambuth on February 2, 1931, with Jewell Reed as the first president and 36 charter members. Boasting colors of blue and white, the club helped students foster a better understanding of the four areas of home economics—sewing and textiles, cooking, nutrition, and entertaining—and taught students "to prepare rare delicacies and sew a fine seam."

These 1941 Lambuth cheerleaders provided spirit for ballgames.

Bettye Lancaster was basketball queen in 1946 and an example of a campus beauty. Basketball resumed that year after a four-year lapse. Other sports queens during the 1946–1947 year included Dorothy England (football queen in 1947) and Virginia Ann Walker (baseball queen in 1947).

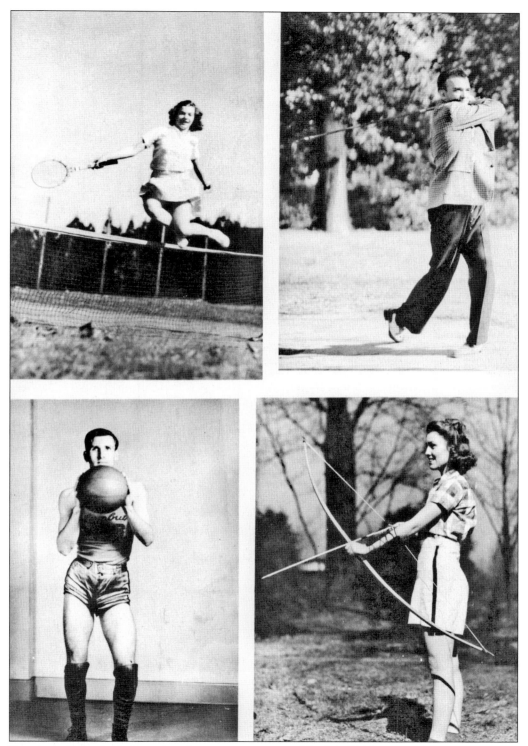

Tennis, golf, basketball, and archery are represented in this 1941 composite.

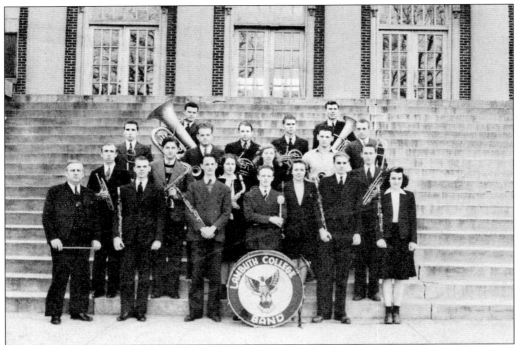

Instrumental music was taught at Lambuth as early as 1925 when the orchestra was made up of violins, saxophones, cornets, banjo, and piano under the direction of Arthur Seeger. The Lambuth College Band, under the direction of Clarence "Pop" Wallick, had come a long way by 1940. They played regularly at chapel and ballgames and performed martial as well as popular music.

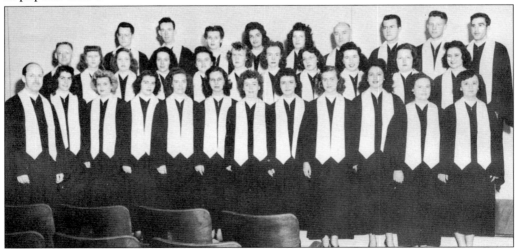

The college choir had a new look in 1945 and performed on weekly radio programs. Students from left to right were (front row) Wheatley, Herron, Moreland, Trevathan, Fowinkle, Allen, Jett, Carothers, Holmes, Breeden, Pafford, and Pafford; (middle row) Thomas, Thompson, Burnett, Gilbert, Crook, Luten, McCormack, Williams, Allen, Richardson, and Stout; (back row) Hester, Latta, Guthrie, Davis, Flack, Evans, Williams, Dismuke, and Bove.

Even during the first days of Lambuth, laboratories were well equipped and included facilities for botany, zoology, human physiology, plant morphology, genetics, bacteriology, nature study, entomology, chemistry, and physics. The university lab, located in the Administration Building in 1945, was a site for hands-on learning at Lambuth and was part of a new, successful curriculum for pre-med students.

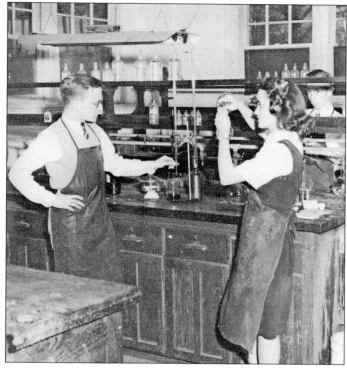

The biology lab on the first floor of the Administration Building was directed by Arthur Oxley, who, along with D.W. Wilson, was responsible for the creation of an arboretum in 1933. The campus boasted the largest sassafras tree "in this part of the country." Many trees were damaged in the tornado of April 18, 1975, which touched down on the front lawn, breaking 100 windows in the Administration Building.

HONOR ROLL

Professor Samuel R. Neel

Horace Lee Adams	Clarence Johnson
James Atterbury	Billy King
Billie Bob Austin	Addison Looney
John Knox Aycock	William Looney
Mallett Barron	Robert McGowan
Charles Branch	Robert McKnight
William Brien	Roger Menzies
Lin Britten	Billy Bob Mosby
James Bryant	Walter Thomas Murray
Paul Burkeen	John Muse
John Capps	James Morris Phillips
Graves Chapman	Meredith Poindexter
Joe Clark	William Richardson
Horace Cooley	Richard Rucker
Walter Craddock	Joe Ryan
Kelton Cuff	Harold Simpson
Wilson Dallas	Fred Standley
Lawrence Dunne	Lanoice Stedman
Edward Exum	Tommy Stedman
Stanley Frye	James Roy Taylor
Lynn Fuzzell	C. B. Thomas
James Garner	James Thurmond
J. C. Gilbert	Walter Lee Underwood
Albert Gillespie	George Vaughn
Murray Gilliam	William Vaughn
William Haltom	Clifton Watson
Thomas Kelly Hardy	Bryan Williams
William Hargrove	Charles Williams*
David Hawkins	James Witherspoon
William Hazelwood	Harold Yarbro

*Deceased

Many students served in the armed forces during World War II. The honor roll of their names from the 1945 yearbook appears here.

The Veterans Club in 1947 included members of the U.S. Armed Services with honorable discharges. The purpose was to strengthen fellowship, promote Lambuth, aid veterans, and promote honesty and industry. The president was Arthur Blankenship and the group had approximately 50 members. Lambuth's first death during World War II was Robert White of Jackson, who was shot down in action while serving in the Canadian Air Force.

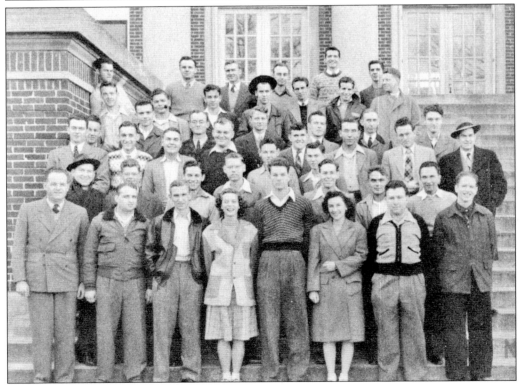

The All-College Social Committee arranged for special events, socials, and activities for the student body. They established a calendar of events for the campus. Shown here in 1948 are George May (chair), Mary Ruth Berry, Wilma Aaron, Harold Lassiter, Deloris Hayes, and Dot McSwain.

The Ruth Marr Chapter of Future Teachers of America was founded in February 1949. It was affiliated with the National Education Association and the Tennessee Education Association. The purposes were professional unity and betterment of the profession. Ralph Hogan was the first president.

The Vision began publication in 1924 with editor C.N. Jolley and business manager Ernest Lewis. The short-lived *Albatross* began in 1948 with editor George Curtiss and associate editor Bill Dunahoo. *The New Vision* was introduced in September 1952 with editor Allen Brewer and associate editor Harry Wilson. Editorial staff included Mary Compton, Geraldine Martindale, Bill Landers, John Batsel, Patty Moody, and Gene Bond. The paper was later renamed *The Vision*.

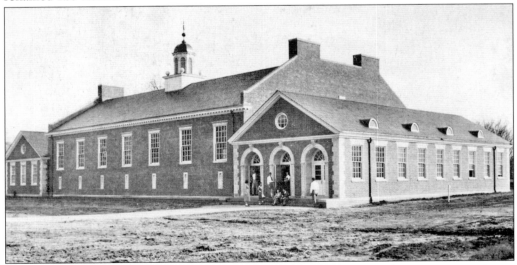

The Lambuth College Physical Education Building was finished in 1948 on West King Street behind Epworth Hall. It housed the gymnasium, offices, locker rooms, game room, and kitchen. The building was renovated in 2000 and dedicated as the Hamilton Performing Arts Center.

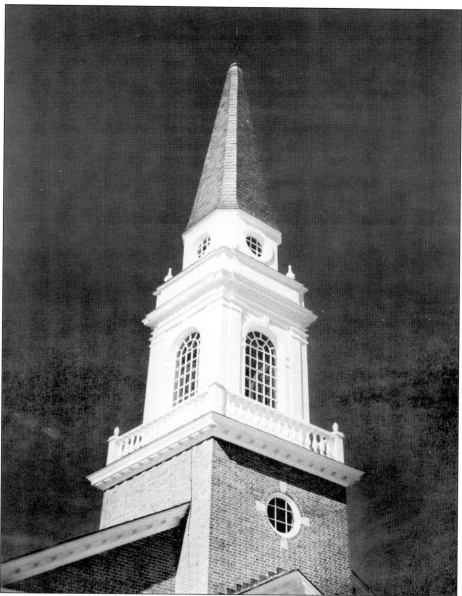

The chapel project began in 1953 and remained incomplete until funds were secured in the spring of 1956. Additional ground was broken on March 8, 1956, for a fine arts wing to the building that would include seven studios, seven practice rooms, and a hall for choir, band, and orchestra practice. Dedication of the cross-shaped chapel occurred April 29–30, 1957. Contributions to the chapel included the Altar Service (cross, candlesticks, and vases), given by the Student Christian Association in memory of Franklin K. Billings; kneeling cushions for the chancel rail by the faculty; eight red maples by Mr. Oxley; and irises given by friends of Lambuth College. The three-manual Bess Taylor Memorial Organ, given by Hays Avenue Methodist Church and the Bess Taylor Service Class, was built by Austin Organs Inc. of Hartford, Connecticut, and dedicated on November 7, 1958. A new Steinway piano was added in 1968. The annual candlelight Christmas service began in 1961 and continues to this day.

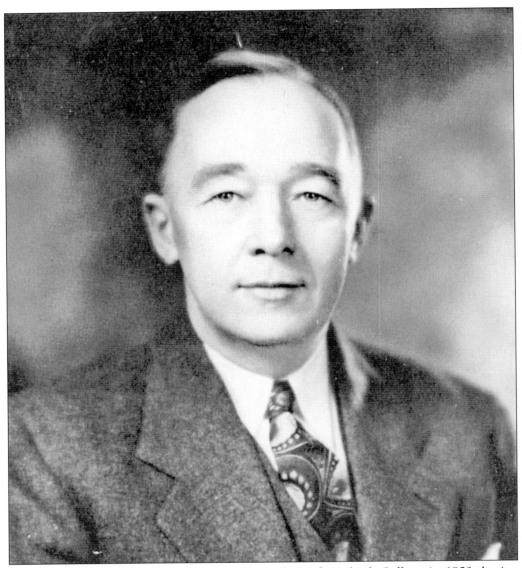

Dr. Luther L. Gobbel became the second president of Lambuth College in 1953, having arrived on campus to meet the faculty and student body on October 12, 1952. He served until 1962. Gobbel had been president of Greensboro College for 17 years. Prior to that appointment, he served as executive secretary of the board of education of the North Carolina Conference. A native of North Carolina, he earned an artium baccalaureus degree from Trinity College, an artium magistra degree from Duke, and a Ph.D. from Yale University. His published works included *Militia in North Carolina in Colonial and Revolutionary Times* (Trinity College Historical Society Papers, 1919) and *Church-State Relations in North Carolina Since 1776* (Duke University Press, 1938). During his tenure at Lambuth, enrollment nearly doubled, the college was accredited by the Southern Association of Colleges and Secondary Schools and by the University Senate of the Methodist Church, the campus doubled its acreage, buildings increased from five to twelve, and teaching staff increased by one-third.

Miss Lambuth of 1951 was Jean East (left). Lou Yancy (center) and Charlotte Stuart (right) were maids.

A Lambuth float carrying Miss Lambuth was a tradition at the May Strawberry Festival in Humboldt, Tennessee. Shown here are Miss Lambuth of 1956, Patty Williams, and her court, Lin Lewis and Gale Boling.

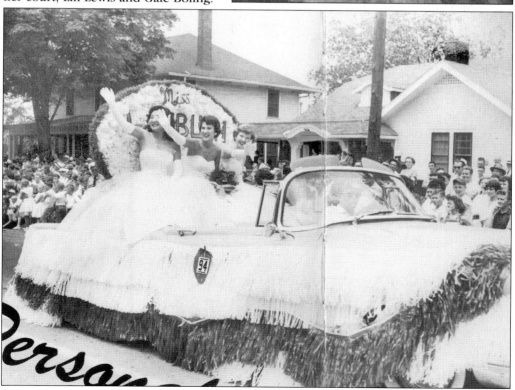

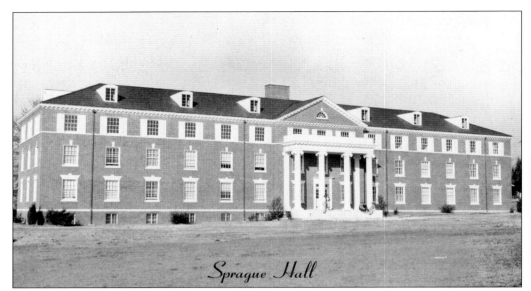

Sprague Hall

Sprague Hall, a dormitory for girls, was completed in 1953 and included rooms for 112 students, a suite for a dean of women, infirmary, kitchenette, parlors, and study lounges. The ground floor contained facilities for a home economics department, including a foods laboratory, clothing laboratory, dining room, kitchen, and breakfast room. Sprague remained a female dorm until 1991, when it became a male residence hall.

Spangler Hall, erected in 1958–1959 as New Dormitory, could accommodate 100 students. Constructed in Georgian Colonial-style with red brick and a roof of blue-black slate, the dorm contained lobbies, a game room, a student lounge, a fully equipped apartment for the residence head, an infirmary, and suites with two rooms and a bath. Rooms were furnished with built-in closets with sliding doors and desks of natural birch finish.

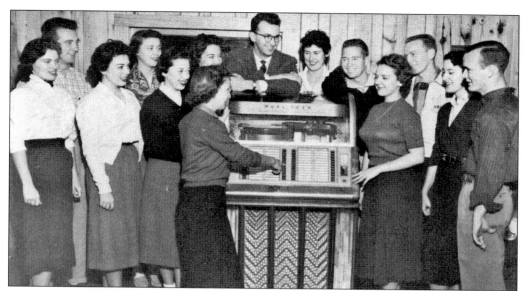

The juke box was a popular feature of the student center. Shown here are members of the All-College Social Committee, including Ann Council, Beverly Bennett, Cherry Moore, Betty Burgess, Pat Thomas, Morris Brile, Frances Brooks, Gloria Fowlkes, George Brasher, Jo Yancy, Jimmy Moore, Bob Hendrix, Dottie Dickson, and Cecil Kirk. This group sponsored the first annual All-College Sing on April 21, 1954, providing musical entertainment by the fraternities and sororities.

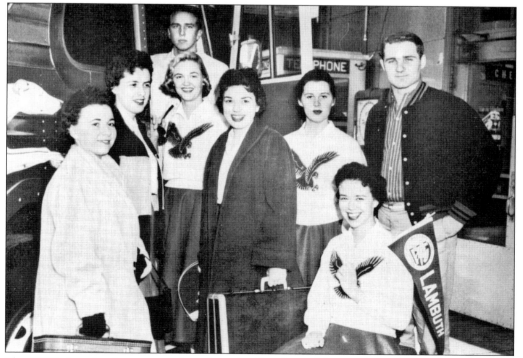

The 1958 cheerleaders are ready to board a Greyhound bus at the Jackson Bus Station for a post-season tournament trip.

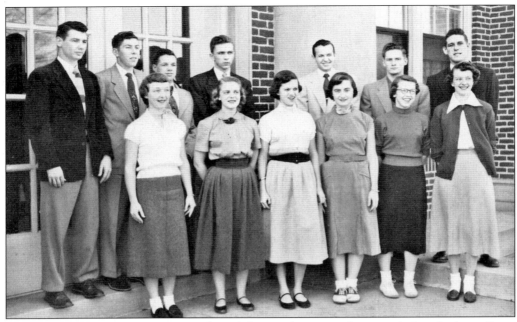

In 1953 student council members, from left to right, were (front row) Dot Barham, Betty Grace Dunn, Barbara Finley, Bettye Branch, Sarah Walker, and Betty Freeman; (back row) Bill Burnette, Harold Gilliland, Jimmy O'Neill, Billy Boon, Howard Laumann, Tommy McKnight, and Carl Dickerson. The executive committee of the Student Government Association functioned as a clearinghouse for student activities and was composed of executive officers of student government, standing committee chairs, dormitory representatives, fraternity and sorority representatives, SCA, and department organization presidents.

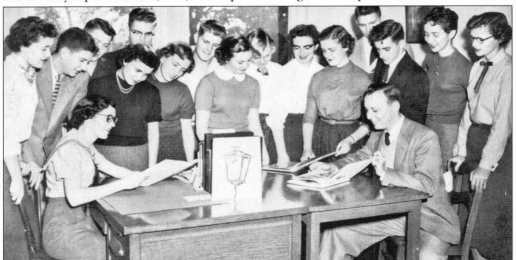

Production began on the first yearbook in November 1926. Its name, *Lantern*, was voted on in chapel, and the publication received financial support from merchants throughout the city. Published in 1927, it was arranged in the form of a play. The *Lantern* yearbook staff is shown in 1955 reading a fresh copy. Quinton Hoffman served as sponsor, Bill Crump as editor, and Sara Crowe and Imogene Joyner as associate editors.

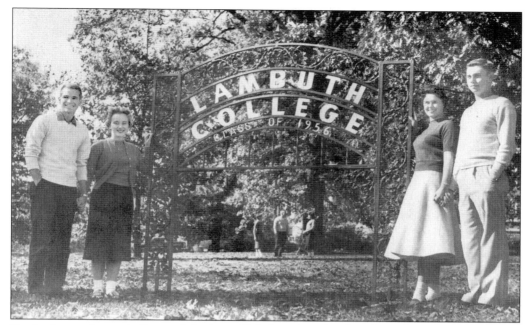

Students are shown in front of the beautiful sign given by the Class of 1956 to the school. Other class gifts over the years have included benches, other furniture, flags, hymnals, and landscaping.

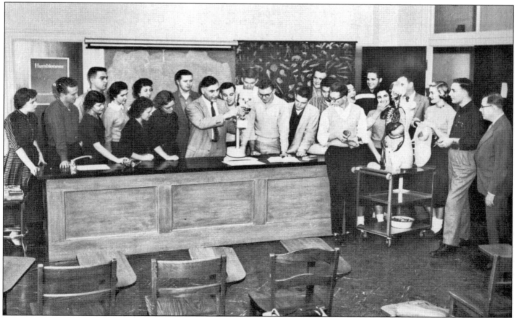

The science club, organized on January 11, 1955, was composed of science majors and minors. The purpose was both educational and social. Its plans included demonstrations, field trips, tours of local industries, slides, and films. Officers were Ben Love (president), Nancy Hamilton (vice president), Ruth Ann Barder (secretary), and Charles Wright (treasurer). In 1956–1957 the president was John Taylor and the sponsor was Mr. Oxley.

The 1957–1958 freshmen class officers—Fred Haley (vice president), Billie Shaw (secretary), Bobbie Pace (treasurer), and Billy Welch (president)—are shown at the popular fish pond on campus. Freshmen were required to wear blue and white beanies and were tested on the student handbook. Violations met penalties such as cleaning the fish pond, sweeping the tennis courts, and wearing stocking caps.

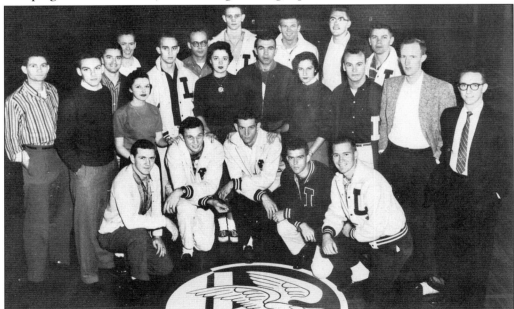

The "L" Club included students who lettered in a sport and who received recognition by the athletic committee. The purpose of the club was to promote college athletics and to promote standards of the Department of Health and Physical Education. Officers in 1958 were Bob Freeman (president), Sammy Smith (vice president), and Craig White (secretary/treasurer).

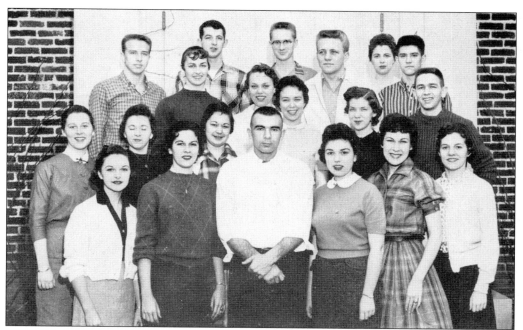

The special events committee arranged significant activities on campus, such as homecoming festivities, beauty reviews, and Christmas and other holiday gatherings. The 1957–1958 members were Betty Burgess, Kitty Richardson, Larry Binkley, Beverly Bennett, Carolyn McDaniel, Barbara Pace, Sandy Johnson, Nettie Jean Johnson, Bobbie Burgess, Gwen McClintock, Sue Ussery, Tommy Moffat, Fred Hanley, Jessie McKissack, Ann Jappe, Gary Rutherford, John Hunt, Curtis Horton, Benny Hopper, and Marjorie Cooley.

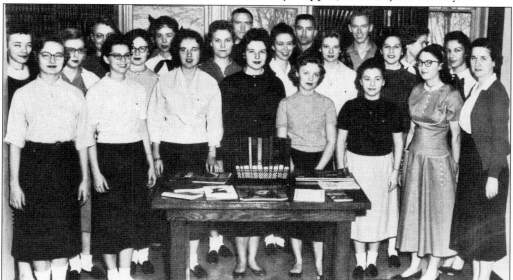

The Student National Educational Association consisted of students preparing to enter the teaching profession. In 1957–1958 officers were Gale Boling (president); Donald Rhodes (vice president); Bobbie Sue Pratt (treasurer); and Maxine Chester (secretary). The Ruth Marr Scholarship was begun in 1967 to assist budding educators.

The dramatic club in 1954–1955 presented four three-act plays: *The Importance of Being Earnest*, *Family*, *Outward Bound*, and *Late Song*. Members in 1955 were Joan Evans, Joe Hill, Martha Smith, Jo Yancy, Blyrna Scarborough, Wilma McCague, Jesse Byrum (sponsor), Sue Malloy, Barbara Adkins, Lydia Seay, John Gilbert, Larry Bond, Frank Frey, Billie Melton, Marjorie Steadman, Virginia Steadman, Nancy Pennington, Jimmy Vann, Neta Bailey, Bill Sissell, Bill Crump, and John Clarke.

Lambda Iota Tau was initiated at Lambuth in 1956 as the first national honorary fraternity for English and foreign language students. Originally, the group was designated the Literary Forum. Shown in 1959 are Cherry O'Donnell, president (seated), and, from left to right, Howard Downey, Shirley Hysmith, Barbara Hearn, Danette Overall, LaNoka Overstreet, Sue Ussery, Bob Leggett, Anne Robbins, Cecil Kirk, Beverly Bennett, Gwen McClintock, Marjorie Cooley, and Tommy Peel.

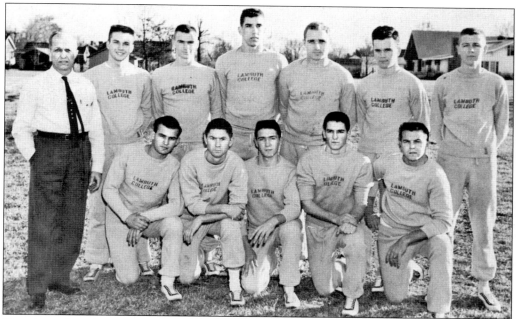

First introduced at Lambuth in 1931, the track team was re-established in 1958 for intercollegiate competition. The 1959 team members, from left to right, were (front row) Phil McClure, Roger Mainord, Don Williams, Charles Russell, and Bob Welch; (back row) Coach Roscoe Williams, Joe Barnes, Joel Clark, Gary McClure, Sidney Peek, Ken Carneal, and Ray Mills. The new athletic field construction plans in the 1950s included an oval track, a baseball diamond, a football field, and four tennis courts.

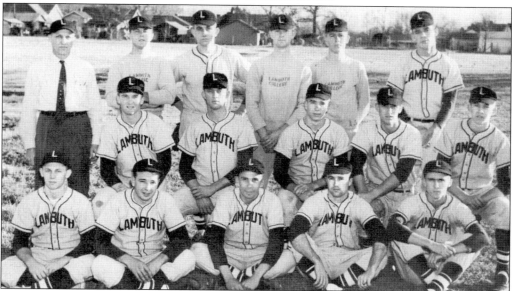

The 1958–1959 Lambuth baseball team members, from left to right, were (front row) Bill Wheatley, Bill Usery, Dale McGee, Bob Welch, and Mike Massey; (middle row) Larry Sanders, Charles Allison, Jack Everette, Bill Henry, and Billy Spellings; (back row) Coach Williams, Bob Welch, John Curlin, Roger Mainord, Ray Mills, and Harold Arnold.

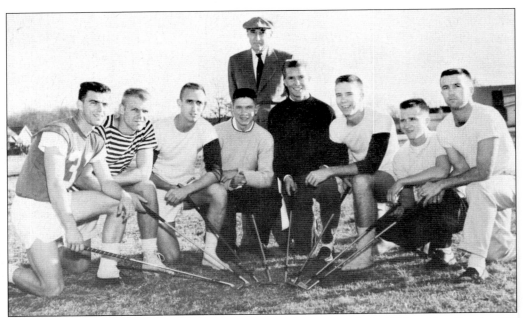

The 1958–1959 golf team was ready for action. Shown are Craig White, Don Lyerly, Bill Henry, Larry Nace, Dean Eagle (coach), Beauford Luckman, Jack Everette, Mack Carter, and Bob Welch. Golf was a Lambuth tradition since the arrival of Professor Eagle on campus.

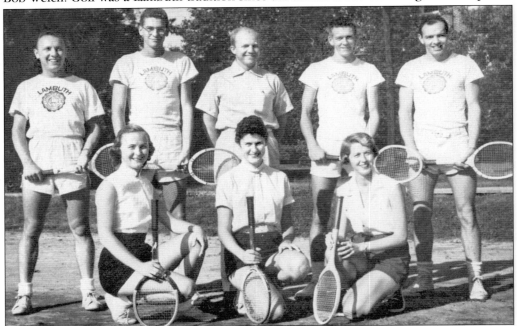

The 1955 Lambuth Tennis Team was represented, from left to right, by (front row) Jane Rose, Jo Yancy, and Vauneida Mitchell; (back row) Bill Crump, Jerry Corlew, Dr. George Keys (coach), Jack Henton, and Ken Burnette. The tennis team had practiced at the home of Dr. Leland Johnson on Walnut Street until the new athletic area was constructed. New, lighted tennis courts were added in 1968.

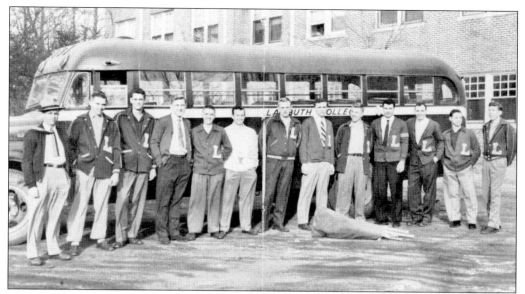

The Lambuth baseball team was ready to travel to an away game on the campus bus in 1952. In addition to athletic teams, the bus traveled throughout West Tennessee carrying the concert choir under the direction of "Uncle Barney" Thompson. The bus is a favorite memory of alums of that era.

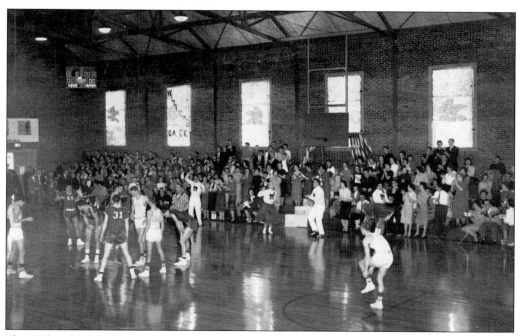

The Richard E. Womack Physical Education Building was erected in 1947. The 1959 team (shown here) brought home six trophies from the Southwestern Invitational Tournament. Statistics during the 1950s included a team average for 17 games of 91.6 points, the highest team total for one game at 145 points against Northwest Mississippi Junior College (with Tom Scott scoring 41), and a team free throw average of 60.7 points.

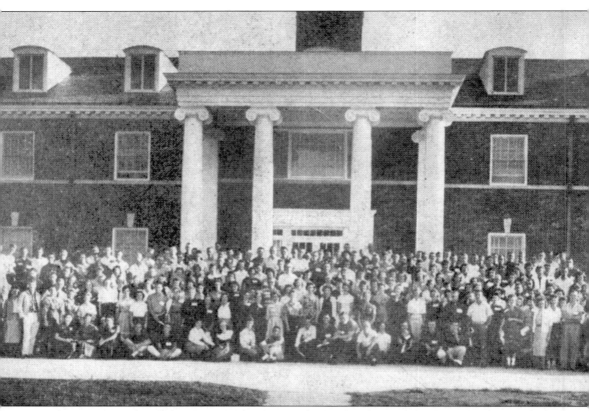

The entering class of 1959 was the largest freshman class in the history of the school, bringing the school's enrollment to nearly 600 students. To accommodate the larger student population, a new dorm and cafeteria were built, a parking lot was added, more programs of study were offered, and new faculty members were hired. Shown are students, camp staff, faculty, and administrators in front of the New Dormitory.

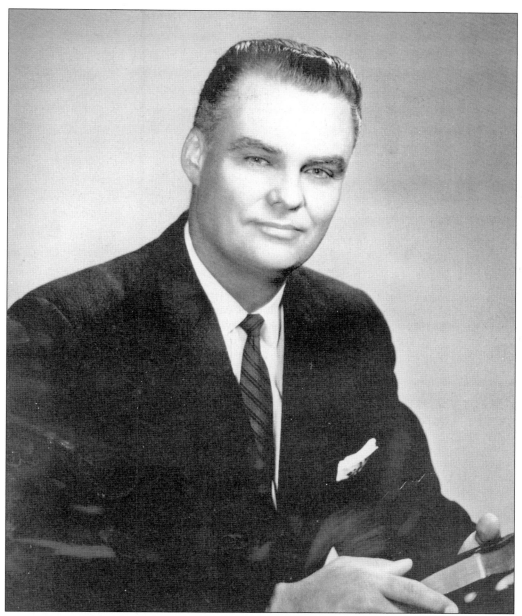

Dr. James S. Wilder became president in July 1962. Born in Washington, D.C., he spent his youth in Clearwater, Florida. He served formerly as minister of Brainerd Methodist Church in Chattanooga and earned his bachelor's degree from Emory, a bachelor of divinity from Yale, and his Ph.D. from Edinburgh. In 1964 he initiated a long-range master plan called "The Great Challenge." Under the plan, four buildings were completed, including the College Union, West Hall, Hyde Science Hall, and the Athletic Center. The full-time faculty doubled between 1962 and 1980. Dr. Wilder retired in May 1980 and assumed the created post of chancellor.

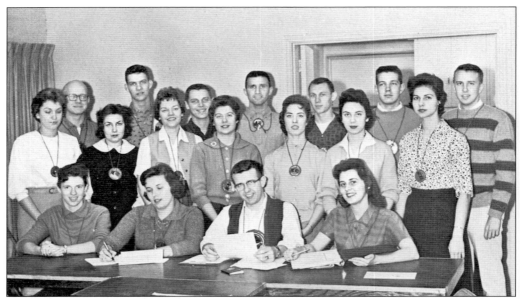

The Student Christian Association promoted religious activities on campus, such as vesper services, service work, and world friendship projects. The members in 1961, from left to right, were (front row) Nancy Hanley, Donna Overstreet, Joe Pennel, and Sandy Johnson; (middle row) Billie Shaw, Cindy Turner, Judy Murchison, Lelia Lowry, Mary Neal Franklin, Janene Dunavant, and Jane Kemp; (back row) Paul Green, Parker Council, Zolon Clayton, Bobby Welch, Billie Wheatley, Charles Callis, and Fred Hanley.

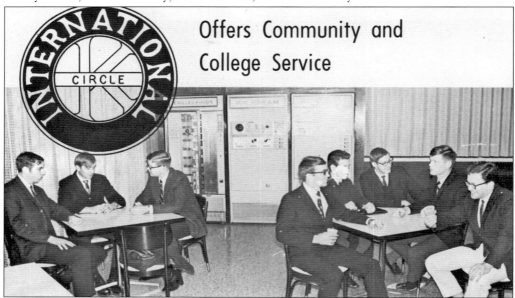

Offers Community and College Service

The International Circle K Club (sponsored by the Kiwanis Club) and the International Club (under the presidency of Oivind Johasen of Norway) were organized in late 1960s. Both clubs emphasized the understanding of other cultures. Members of the 1966–1967 Circle K Club, from left to right, were Max Hulme, Barry Henson, Jim Polk, Mickey Carpenter, Ed Love, Tommy Haynes, Cliff Morrison, and Matt Ford.

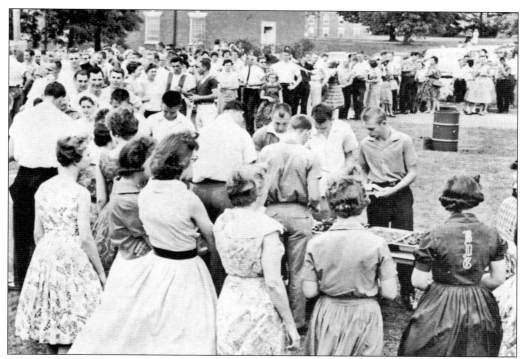
The spring all-campus picnic is shown in 1961.

The air-conditioned J.A. Williamson Dining Hall was completed in 1959 with seats for 400 students. It also housed a private dining room and facilities for food service. The second floor housed classrooms for art, speech, and drama. In 1967, an art gallery was created on the second floor, providing exhibit area for local and nationally renowned artists.

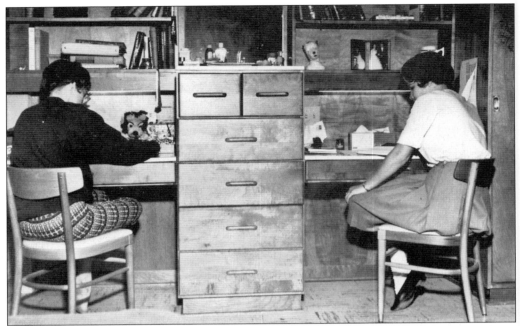

Two students are studying in their new dormitory rooms, where built-in desks and chests of drawers accommodated living needs. Harris Hall, a residence for women occupied in the fall of 1961, could house 122 students in a three-story structure that included bedrooms connected with baths and social, recreational, and study space.

West Hall for men was dedicated on May 7, 1967. The three-story building contained four-men suites and housed 200 students. It was carpeted, air-conditioned, and quite modern for the time. The 1967–1968 hall council members were Ed Nasca, Tom Akin, Darrell Reiners, Tom Taylor, Robert Hopper, Ed Tonahill, Jim Copper, Ed Thompson, Joe Abrahams, Doug Kroll, and hall sponsor Mrs. Cross.

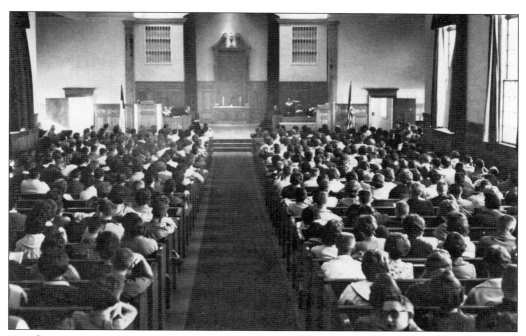

Worship service in Womack Chapel is shown in 1961. In addition to religious services, students in 1962 enjoyed chapel programs that included musicians, Lambuth professors, religious leaders of all faiths, scientists, and the school's president. Compulsory chapel was abolished on May 13, 1968, by vote of the faculty.

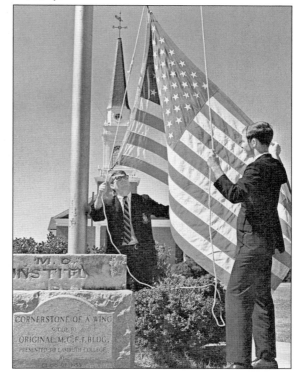

The flag is raised by two student government leaders at the 1966 Opening Convocation as a symbol of the official opening of the term. The flagpole area includes the cornerstone of a wing added to the MCFI building, restored and presented by the graduating class of 1955.

Lambuth coeds are ready for the spring formal in 1963.

Gamma Omicron Chapter of Kappa Alpha Order came to Lambuth in 1958. "For God and Women" is the motto of the order and their house near campus is a fraternity gathering place. Students dressed in traditional antebellum style for their annual Old South Ball in 1967.

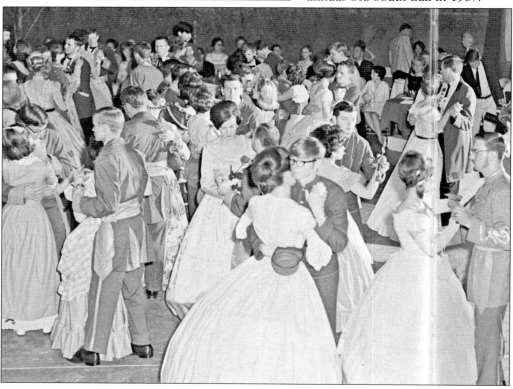

Who's Who Among Students in American Colleges nominees are selected by the student awards faculty committee each year, having begun in 1943. The award is based upon character, scholarship, and leadership. The 1965 Who's Who recipients were Beth Bond, Alta Burnett, Mike Butler, "Bernard" Pung Cheng, Sammie Fisher, Bettye Ruth Clement, Bill Hamer, Ho Ka Hang, Marjorie Helms, and Mary Nelle McLennan.

Class favorites were elected by their classmates in the 1960s. In 1967 the favorites were seniors Becky Thurston and David Whetstone, juniors Paula Gilbert and John Hostetler, sophomores Rhea Farrar and Bill Nunnally, and freshmen Judy Lewis and Will Crellin.

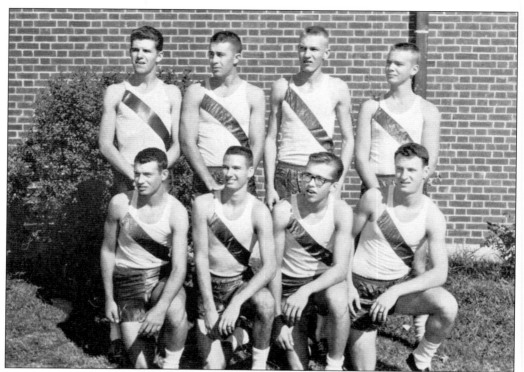

The cross country team members in 1963, from left to right, were (front row) Buddy Maness, Don Watson, Bobby Landrum, and Dwight Mills; (back row) Chuck Livingston, Jimmy Johns, Kenny Strong, and Skippy Hawks.

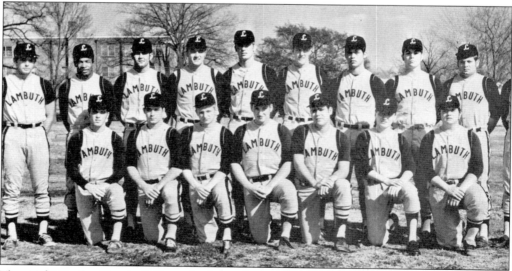

The 1969 Eagles Baseball Team had a 5-6 season record. Team members, from left to right, were (front row) Pete Lyons, Jim Dillard, Rossy Williams, Wayne Henson, Thomas Mitchell, Ed O'Reilly, and Greg Molinaro; (back row) Bill Hafler, Willie Peete, David Strickland, Paul Bolduc, Jeff Buchholz, Ivan Criner, John Summers, Dale Walfrom, Ross Luther, and Mike Maynard.

The auditorium-style lecture hall (room 215) in the new science hall is shown on its opening in the fall of 1967. The science hall (renamed Joseph Reeves Hyde Science Hall in October 1976 in honor of the late philanthropist) housed the planetarium, computer center, thermonuclear lab, observatory, greenhouse, biology and chemistry labs, and facilities for physics and mathematics.

Luther L. Gobbel Library, first occupied in fall 1961, was built with funds contributed by the Kresge Foundation and other contributors. The four floors housed books, periodicals, and reference collections with a capacity of 100,000 volumes, as well as audiovisual equipment, offices, seminar rooms, a treasure room, a prayer room, a language laboratory, and listening facilities. In 1968 the library became an official depository for federal government documents.

In the fall of 1966 the Student Union Building was dedicated, the ground having been broken on September 24, 1965. It included a ballroom, formal guest lounge, private dining hall for the president, snack bar, self-service bookstore, student lounge, post office, barbershop, recreation room with ping-pong and pool tables, a sound-proof listening room, modestly equipped classrooms, and offices for members of the administration and faculty. The Blue and White Center, a small, temporary building built in 1958, had served as the students' hang-out, where they played cards, listened to the juke box, and visited the snack bar and small post office. The Student Union Building was renamed College Union Building in 1967 to provide better utilization. It became the location for movies, faculty-student mixers, and card playing. It was renamed once again in honor of President Wilder on May 5, 1985.

Four

WIDENING THE VISION
1970s–1980s

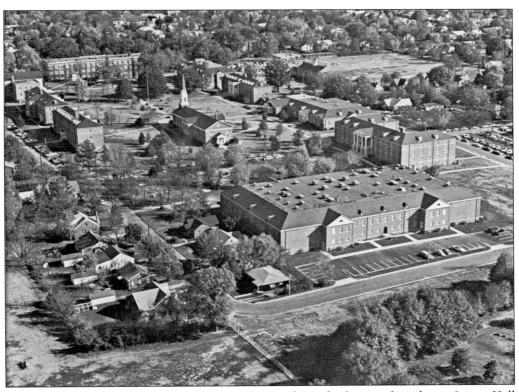

The campus in 1971 from the Athletic Center through the quadrangle to Jones Hall represents the physical growth period of the college. Today's structures have been renovated, but new buildings have not been added.

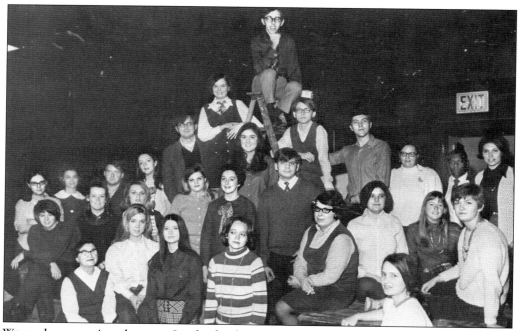

Womack gymnasium became Lambuth Theatre in 1970. The first production in the new facility was *Blythe Spirit* and was directed by Jesse Byrum. The Attic Players were students involved in the Lambuth Theatre productions and in 1970 included Wilma McCague (director) and students Rogers, Howard, Lindecker, Sacarakis, Stovall, McPherson, Irwin, Moore, George, Zelner, Nance, Meredith, Kirk, Gray, Wood, Haag, Smith, Roberts, Gaugh, Hurt, Mathews, West, Pyron, Cook, Baldwin, Butler, and Horner.

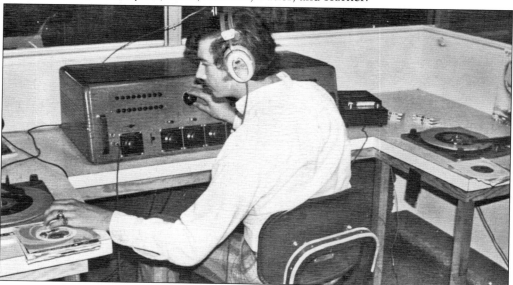

In 1970 Lambuth began broadcasting on WLAM (640 AM) from 3:00 p.m. to midnight. Music, talk shows, and radio dramas were popular. The student-managed, student-operated station was under direction of the drama department and was located in the Day Student Lounge of College Union.

Kappa Alpha in 1970 included students Williamson, Hamer, Scott, Thomasson, Montgomery, Temple, Colburn, Rabold, Mills, Parks, Tynes, Smith, Harris, Groves, Teirney, Whalley, Goodman, Wilder, Robbins, Hopper, Page, Norstrom, Paige, Lowdermilk, Wagster, Davidson, Bidwell, Lyons, Watlington, Hardison, Yarbro, Collier, Bomar, Collier, Groff, Jetton, Bott, McSwain, Massey, Boone, Thomas, Fulenwider, Atkinson, Prange, Pendergrass, Cardwell, McCalla, Yarbrough, Thompson, Conway, Coulette, Neal, Mabry, Lewis, Gurley, and Wagster.

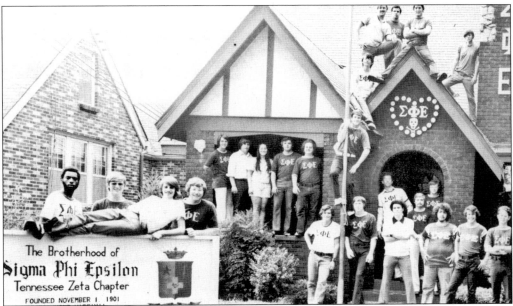

Sigma Phi Epsilon, Tennessee Zeta Chapter, members are shown outside the fraternity house in 1973 and include students Rooks, Hurst, Mueller, Hill, Flanders, Allman, Pressgrove, Brill, Jackson, Chappin, Golden, Cartwright, Murray, Matthews, Rogers, Gowan, Bewick, Brewster, Kaiser, Welch, Masuoka, Westrich, Mahr, Key, Volk, and Lowry.

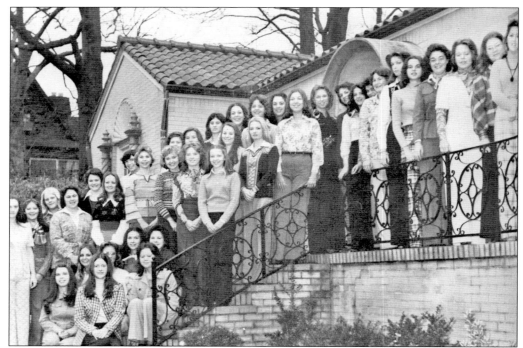

Members of the Gamma Xi Chapter of Sigma Kappa sponsored such events as the Founders Day banquet, pancake breakfast, and spring formal in 1975–1976. Members were students Fisher, Freeman, Terrell, McClure, Townsend, Pearce, Compton, Pickett, Scott, Cary, Daniel, Malone, Miller, Cromwell, King, Brantley, Holmes, Chipman, White, Sorgenfrei, Roberson, Brown, Humphreys, Billings, Sturdivant, Comes, Kirkscey, Sisson, Phillips, Dawson, Waterhouse, Smith, Poteete, Mercer, Threkeld, Allen, Sears, and Morehead.

A coffeehouse was established by students in a wing of the old gym on Friday, October 9, 1971, and was named the Glass Onion. Open on Wednesday and Friday nights, the coffeehouse offered local entertainment, "heavy rapping," and hot spiced cider, coffee, and Russian tea. An earlier coffeehouse, "Back Room," met on the first floor of the Butler House in 1969.

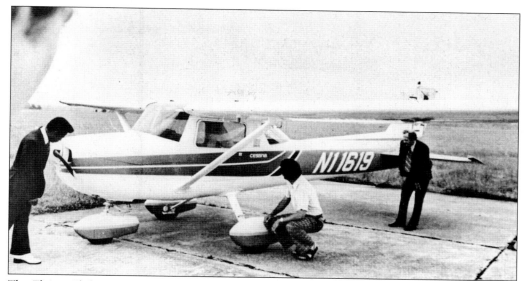

The Flying Club was organized in 1973 under the direction of sociology professors Charles "Chuck" Baker and Gaylon Greer. It was open to students who were interested in flying under FAA regulations. In March 1974 the club purchased a $12,000 Cessna 150, financed through the Jackson Flight Center. The cost to join the group was a $15 initiation fee and $10 monthly dues. Instruction took place at the McKellar Field Airport.

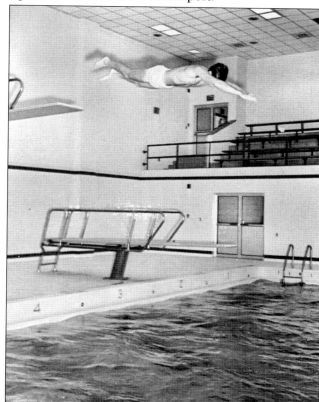

The A.A.U. regulation pool area served the sport and recreational needs of students from the opening of the Athletic Center in 1969. The 85,000-square-foot center also housed two gyms, a handball court, weight room, gymnastics room, classrooms, training rooms, and offices.

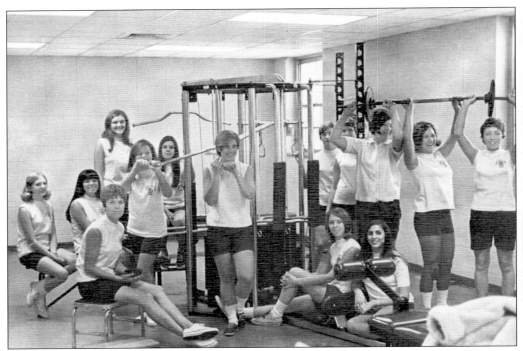

The Women's Physical Education Majors' Club began in 1970 and promoted women's physical education as well as women's varsity sports. The club set aside space in the Athletic Center for study, exercise, and relaxation.

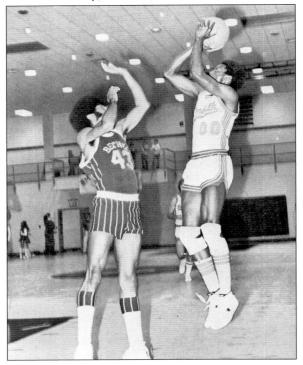

Senior Rickey Delk became the first basketball player in the college's history to score more than 2,000 points in a career. He finished the 1975–1976 year with 2,327 points and made 46 points against Southwestern (Rhodes) for an all-time individual game record. Delk led the VSAC in scoring for three years, was named the Western Division's Most Valuable Player for 1975–1976, and made All Conference Player, averaging 28 points per game.

The Lambuth Jazz Band and Kaleidoscope toured Washington, D.C., and New York City as part of the Public Relations Through the Performing Arts project in 1975. Under the direction of Dick Brown and Frank Coulter, the groups met Tennessee officials, visited historic sites, and promoted Lambuth. The Jazz Band performed big band, modern jazz, and popular music at ballgames, high school assemblies, and other functions.

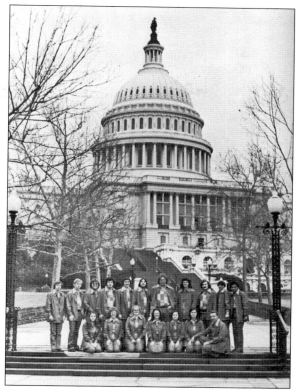

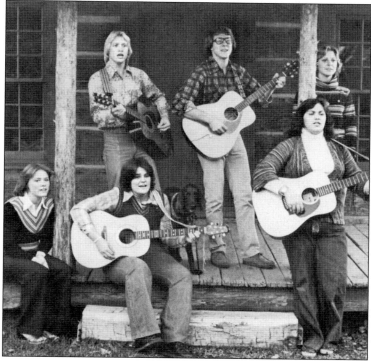

The six-member singing group Harvest worked in conjunction with the admissions office in recruiting students. The troop was featured for Parents' Weekend in November 1978 and performed at numerous banquets on campus and at churches in the Memphis Conference. Members, from left to right, were (front row) Carla Gilland, Judy Luther, and Helen Harrison; (back row Jim Irvin, Tripp Cooke, and Debbie Seiffert.

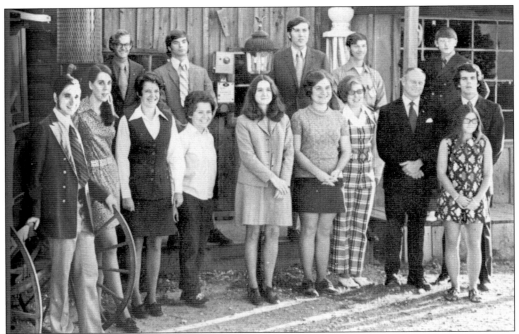

Formed in 1969 to encourage interest in regional history, the history club took trips to the Hermitage, Upper Room, Parthenon, Shiloh, and Memphis, among other historic sites. In 1972 the members were Steve Crosby, Susan Farr, Jean Dawkins, Ruth Ann Grant, Sylvia McCullar, Brenda Goodrum, Bebe Christopher, Becci Matlock, Larry Greer, Larry Crawford, John Cook, Tom Nabrowski, Frank Christopian, Bill Stepp, and sponsor Bob Mathis.

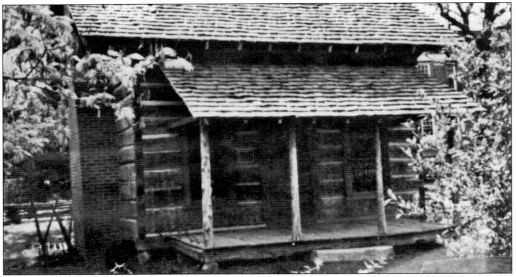

Marking Tennessee's bicentennial year, Lambuth dedicated the Dunlap-Williams Log House Museum of Early America on November 7, 1976. It was given by the late Earl T. Dunlap and Mary Williams Dunlap of Bells, Tennessee. The cabin was dismantled from the original site by volunteers and reassembled on the campus, where it remains today. Its purpose was to display pioneer and Colonial artifacts, antiques, and memorabilia.

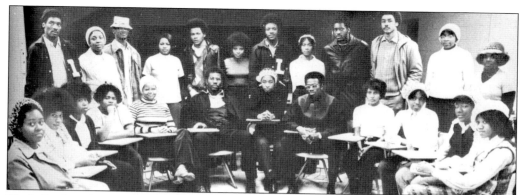

Black Student Union was one of the largest student organizations in 1972 and sponsored social nights, talent events, Martin Luther King services, Black Extravaganza, Ebony Ball, and Black Band Day. The members in 1972 were students Glenn, Wilson, Session, Hayslett, Stewart, Walter, Parker, Mercer, Strong, Cathey, Bledsoe, DeGraffenreaid, Baker, Shaw, Young, White, Jackson, Waits, Gardner, Williams, Newson, Taylor, DeBerry, and Holland.

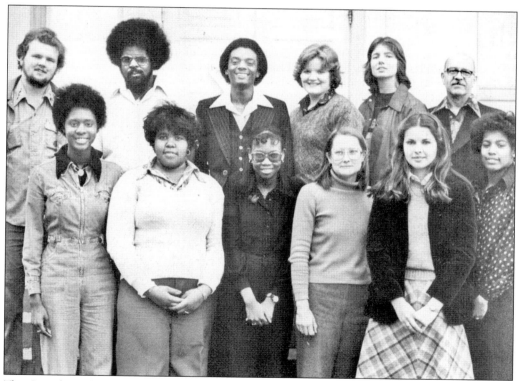

The Social Work Club was organized in September 1978 for those students interested in social work as a profession. Shown here from left to right are (front row) Kim Dixon, Patricia Taylor, Janice Bowman, sponsor Joy Finney, Lisa Lagenbach, and Debra Tate; (back row) Rodney Parker, Vernon Weathers, Derrick Allen, Ann Markham, Pam Spitznas, and sponsor A.T. Tanner.

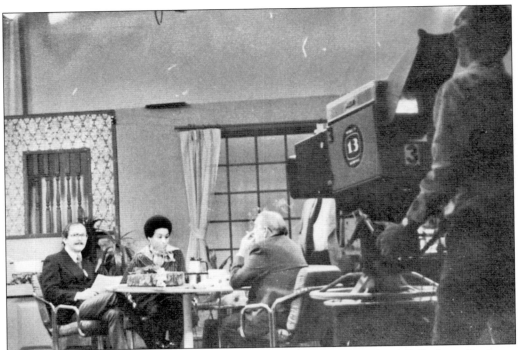

Channel 13 in Memphis carried Marge Thrasher's program "Straight Talk," where Dr. Larry Ray talked about the college's interior design program, which was located in a new interiors house on West King. The program also offered a pre-architecture program in 1976.

Interior design was a fast-growing major in 1975 and the only program of its type in the Mid-South. Combining art, business, and family development, the program offered internships throughout the region. A showcase home designed by students was sponsored regularly by the department, under the direction of Larry Ray and Nelle Cobb. A student chapter of the American Institute of Interior Design was established in 1973.

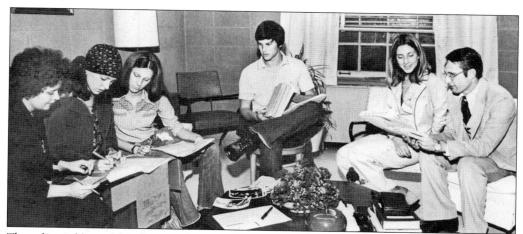

The editorial board for the *Lantern* worked in 1977 on a copy for the new annual. Members were, from left to right, Ruth Ann Grant, Mrs. Susan Hudacek, Kathie Smith, Ricky Snellgrove, Jane Spencer, and Dr. Ronnie Barnes.

Brenda Pearce, Dr. Charles Mayo, Nancy Miller, and Dr. Gene Davenport discuss topics of interest in this Sunday night "rap session" at Chaplain Whitehead's house in 1976. It was not uncommon for faculty members at Lambuth to invite students to their homes for informal discussion groups and meals.

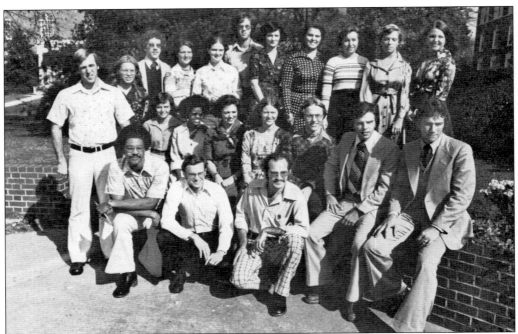

On October 22, 1975, 21 seniors were named to Who's Who Among American University and College Students. Honorees were, from left to right, (front row) Toney Walsh, Art Taylor, Joe Watlington, and Rick Boggs; (middle row) LuAnn Brentson, Robin McKinley, Gwen Green, Linda McBride, Jane Terrell, Tom Byrum, Hugh Exum, and Chuck Keltner; (back row) Steve Rayburn, Kathy Turner, Donna Whitten, Gil Webb, Anne Blair, Kathy Williams, Karen Sorgenfrei, Toni Miller, and Kathy Davis.

Gamma Beta Phi was an honorary society for high-achieving students that promoted scholarship and service. It was reinitiated in 1975 under the leadership of Dr. Russell McIntire. Student members were Terrell, Droke, Miller, Griesheimer, Davis, Parson, Hight, Parham, McGoughy, Tiffin, Wagster, and Inman; (middle row) Fralich, Anderson, Wright, Hartz, Griffin, Byrum, Wilkerson, Smith, Hill, Watlington, Williams, Davis, Conley, Blair, Alexander, Carter, Rayburn, Pressgrove, Corum, Lawrence, West, Jeffries, Johnson, Waterhouse, Hayes, McBride, and Poindexter.

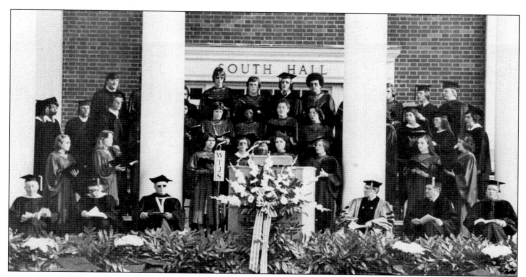

The 128th Commencement exercises were held in the quadrangle with the platform party on the South Hall patio on May 23, 1976. Dr. Alexander Heard, chancellor of Vanderbilt University, was the speaker, and 184 diplomas were conferred. Bishop Frank Robertson served as baccalaureate speaker. Cathie Carter received the Sigma Kappa Scholarship Award, Kathy Williams received the R.E. Womack Outstanding Senior Award, and Arthur Taylor received the AOPi Outstanding Service Award.

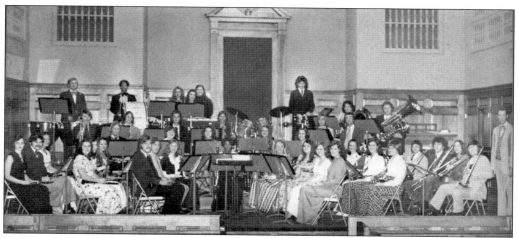

The concert band participated in the first Tennessee All-Star Collegiate Bands at Dyersburg and Knoxville in 1975. Directed by Dick Brown, the band performed annual winter and spring concerts in Womack Chapel.

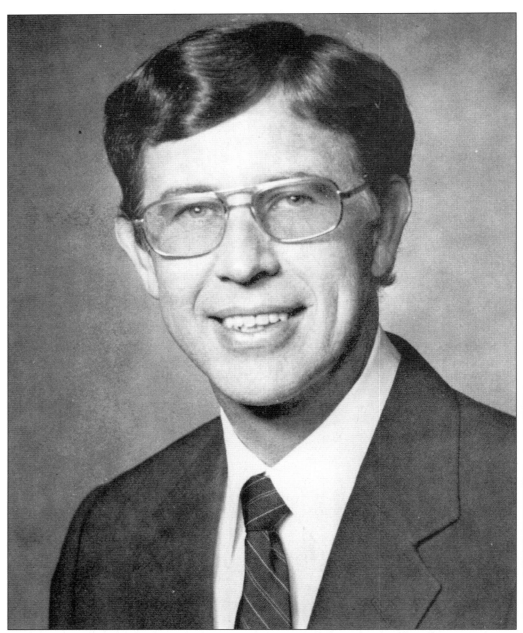

Dr. Harry Wesley Gilmer was elected president of Lambuth College on February 5, 1980, and assumed duties on June 1, 1980. Born April 11, 1937, he graduated from Emory and Henry College cum laude with a bachelor's degree in English and history. A bachelor's degree in divinity was completed at Candler School of Theology at Emory University in 1963. In 1969 he was awarded a Ph.D. from Emory in biblical research and Near Eastern religious history. He served as associate dean of the college at Wesleyan College in Georgia and dean of the faculty and professor of religion at Millsaps. He served as president at Lambuth from 1980 to 1986. During Gilmer's presidency, there was an increase in recruitment of international students and football returned to the campus.

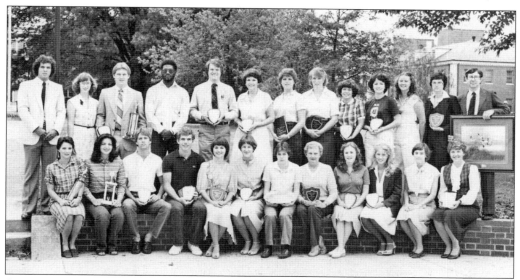

On May 11, 1977, the Student Government Association instigated the first Outstanding Educator Award, which was presented to Dr. Larry Ray, associate professor of art and interior design. The Honors Convocation was held on May 13, 1981, and honored the following students: Bulle, Hereford, Hickey, Lanier, Goodwin, Powell, Dreher, Bowers, Burnette, Barnette, Shannon, Meriwether, Lewis, Kilzer, Kirby, Hughes, Smith, Vandeven, Wilhite, Shelby, Trusty, and Jerstad.

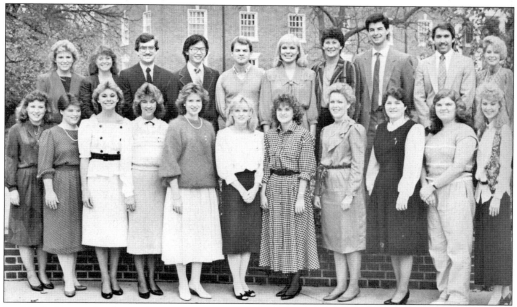

In 1985 21 Lambuth students were chosen as Who's Who Among American Colleges and Universities. Mrs. Evelyn Whybrew gave the convocation address. Recipients were Valerie Booth, Sherry Crump, Kelly Donahoe, Marti Dorris, Sally Doyle, Beverly Ezell, Lyda Harris, Mary Hartman, Diana Howard, Paul Jackson, Rachel Jackson, William Leathers, Anne Lee, Gay Lester, Catherine Lott, Michael McWhether, Malea Mullins, Jerri Norville, James Ramsey, Deborah Roberts, and Hung Tran.

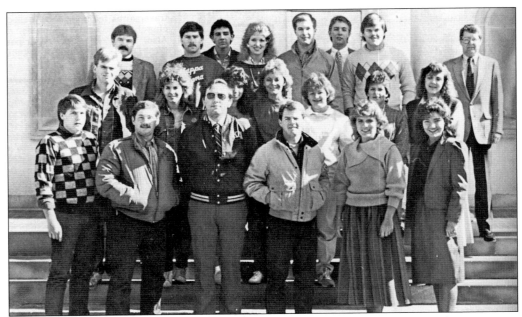

The Student Government Association sponsored a "Back to the Island" party, homecoming weekend, the Paula Bridges Band, the Christmas party, a back-to-school January dance, a computer dating service, a Valentine's dance, and the Miss Lambuth pageant during the 1985–1986 academic year. Members, from left to right, were (front row) Owen, Ward, Bonczar, McWherter, Norville, and Stanton; (middle row) Hartman, King, Lewis, Howard, Myers, Bugg, and Womack; (back row) Finney, Garner, Schmidt, Walker, Spence, two unidentified students, and sponsor Paul Finney.

The 1979–1980 sociology club, under Dr. Roger Bates, sponsored the annual Buffalo River canoe float, entertained at the Hub, participated in the Mid-South Sociology Society meeting, and sponsored the annual West Tennessee Undergraduate Sociological Symposium. Members were students Vandeven, Evans, Vaughn, Wilhite, Spitznas, Wiley, Irving, Wells, McCalla, Norville, Evans, Barron, Bowman, Anderson, Carter, Akers, Waldrip, Hemby, Gillis, Finney, Greer, Williams, Pool, Cole, Thomas, Cate, Fletcher, Young, Snipes, and Archer.

Students study and relax in residence hall rooms in 1986. Each room reflects individual tastes in decor, organizations, and style.

The first West Tennessee Designer Showhouse was held April 16–30, 1978, at the historic McKinnie home at 549 East Main Street. In the spring of 1979 members of the Lambuth Chapter of the American Society of Interior Designers, under the direction of Dr. Larry Ray, transformed Epworth Hall into a "personality showcase," consisting of 22 decorated apartments, each depicting a celebrity.

Kaleidoscope was formed in 1970 by Professor Coulter. The group performed for various clubs, civic organizations, and churches of all denominations. They began a tradition in 1977 with a Madrigal Dinner in the Colonial Room.

The concert band in 1988 presented fall and spring concerts and traveled each semester to area venues.

At the first home football game in 38 years, the Eagles set the field in blue and white. The coaching staff included Andy Rushing, O'Neal Henley, Bobby Wilson, and Myron Johnson. The uniforms were silver-gray pants with blue and white stripes down the side, blue jerseys numbered in white, and white helmets with blue faceguards. Jackson Central Merry's band played. Other festivities included a pep rally, cookout, and post-game parties.

Fans catch the Eagle spirit during a Lambuth football game in 1985.

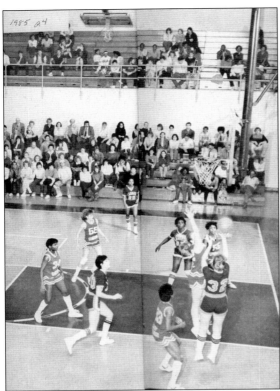

The Lambuth Lady Eagles play at home in the Athletic Center in the winter of 1985. They were coached by Sherry Smith, who also coached the tennis and volleyball teams and sponsored women intramurals.

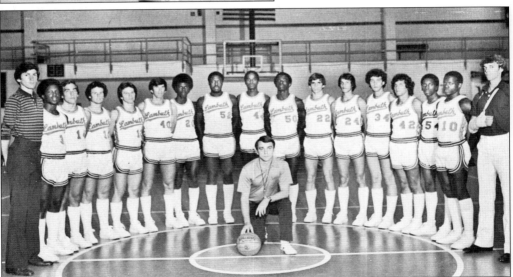

The Eagles basketball team won the 1980 VSAC crown. Coach Charles "Pepper" Bray, completing his ninth year as coach, won Coach of the Year in the Volunteer State Athletic Conference. Team members from left to right were David Bartlett, Joe Neeley, Edward Martindale, Syd Freeman, Ray Walters, Reggie Kilzer, Tony Dawson, Adrian Nathaniel, David Gholston, Terry Martin, Brent Dreher, Randall Moore, John Phillips, David Wilkins, Elbert Donelson, David Delk, and Steve Wade.

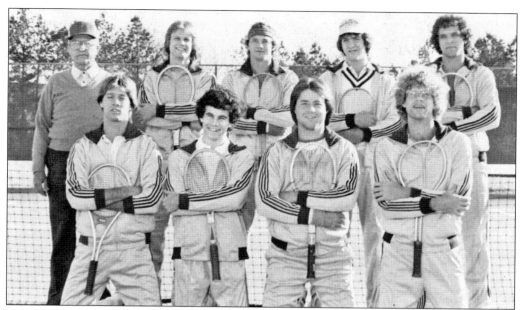

Members of the 1980 men's tennis team were, from left to right, (front row) Jim Powell, Ricky Vaughn, Sean Locke, and Lee Graham; (back row) Coach Roscoe Williams, David Thompson, Richard Bacon, David Rudd, and David Wilkins. Women's team members were Sally Carpenter, Kim Gilliland, Regina Duncan, Suzanne Fletcher, Missy Walsh, Elizabeth Evans, Mary Clayton, Maryann Thompson, and Ellen Evans, with Norma Ellis as their coach. The first VSAC women's tennis tournament was co-hosted by Lambuth and Union University.

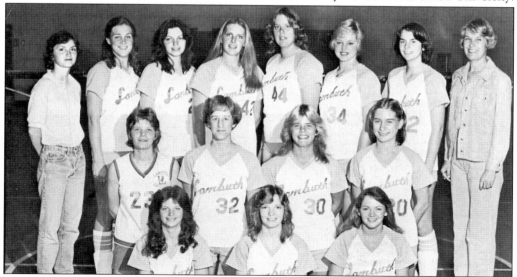

The second women's VSAC volleyball tournament was held at Lambuth in 1979. Other tournaments for the team were the Sewanee International and the Milligan College International. Members, from left to right, were (front row) Missy Lewis, Leda Whitwell, and Lisa Davis; (middle row) Sherry Goforth, Brenda Bowers, Debbie Exum, and Gaye Chandler; (back row) Marian McCaghren, Missy Walsh, Marcia Lewis, Melodie Schmidt, Nancy LePinnet, LeAnn Freeman, Donna Rhodes, and Coach Norma Ellis.

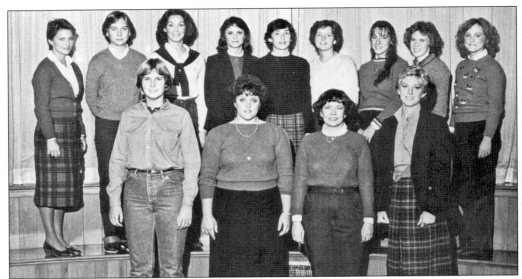

The Panhellenic Council in 1981–1982 worked toward inter-sorority relationships, maintaining high social and scholastic standards and providing a forum for discussion. Greek rush and All-Sing were sponsored events. Members, from left to right, were (front row) Holly Holland, Laura Schubert, Kim Kirby, and Ellen Evans; (back row) Sally Hardgrave, Gaye Chandler, Sherry Moore, Lynn Shaw, Mary Lloyd Lynn, Kara Leigh Hunt, Ann Ewing, Melinda Jennings, and Kathryn Anne Barker.

Kappa Sigma fraternity in 1985–1986 obtained the largest number of pledges during rush. Members were students Bock, Campbell, Campbell, Capps, Clarke, Clement, Corbitt, Coyne, Craig, Darnall, Farmer, Garner, Gibson, Goldberg, Hare, Hutcheson, King, Kirk, Lanier, Larson, Leathers, Morel, Overbey, Page, Pattat, Parker, Parker, Raines, Reeves, Roberson, Stephenson, Teer, Todd, Williamson, Wong, and Wood.

The AOPi Omega Omicron Chapter has cardinal as its color and the rose as its flower. The 1980 members were students Morris, Boone, Meacham, Bass, Hunt, Cate, Parker, Coggins, Copper, Dickey, Solomon, Lowry, Schubert, Haywood, Peacock, Gilliland, Jennings, Gowan, Greer, Stewart, Johnson, Douglas, Moore, Wade, Harris, Warren, Moore, Wilder, Fields, Shelby, Markham, and Holland. In 1985–1986 the chapter sponsored a Bahamas Bash, a parent tea, a faculty tea, and the Rose Ball.

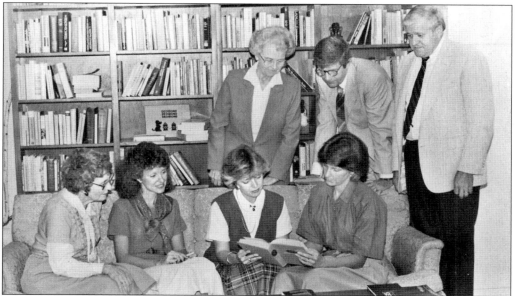

The English department faculty poses for the *Lantern* picture in 1986. The faculty included, from left to right, (seated) Grace Whetstone, Susan Hudacek, Joy Austin, and Kathy Anderson; (standing) Annie Smith, Charles Mayo, and Bob Hazelwood (chair).

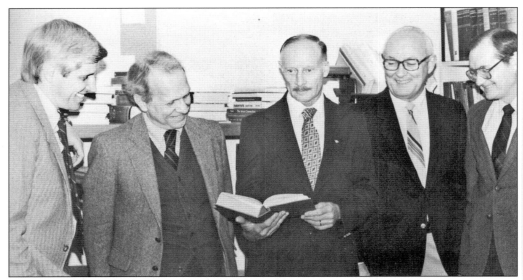

Religion, philosophy, and history faculty gather for the yearbook picture in 1986. They include, from left to right, Rusty McIntire, Gene Davenport, Robert Mathis, Brady Whitehead, and Kenneth Wilkerson.

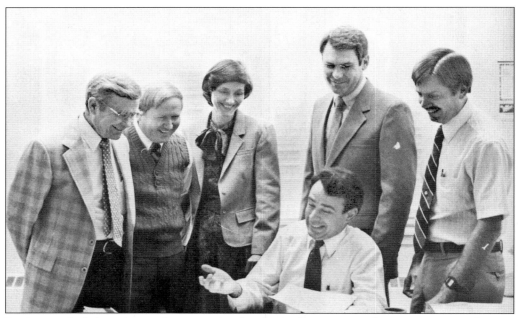

Business administration and economics faculty gather to consider a new curriculum in 1986. They include, from left to right, (seated) Bill Anderson, chair; (standing) Delbert Hurst, Wilburn Lane, Melinda Pearson, Jerry Peters, and Sam Faught.

Dr. Harry Gilmer and faculty process back to the Jones Administration Building after baccalaureate services in 1986.

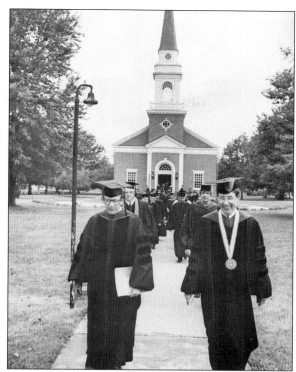

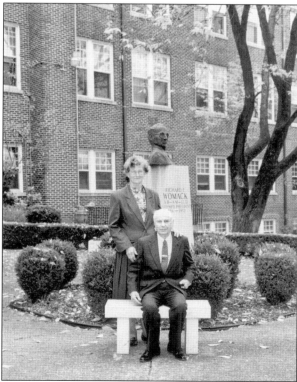

The Richard E. Womack Memorial Garden was dedicated on May 24, 1980, with money raised by Rev. and Mrs. Artie Bivens, Elizabeth Boren, Rev. Marcus Gurley, Helen Ross, and Jewel Tucker. Dr. Larry Ray designed the area and sculpted the bust of Dr. Womack, which was cast in bronze and placed on a Georgian granite pedestal. Shown here are Mr. and Mrs. Hollis Liggett, longtime supporters of Lambuth.

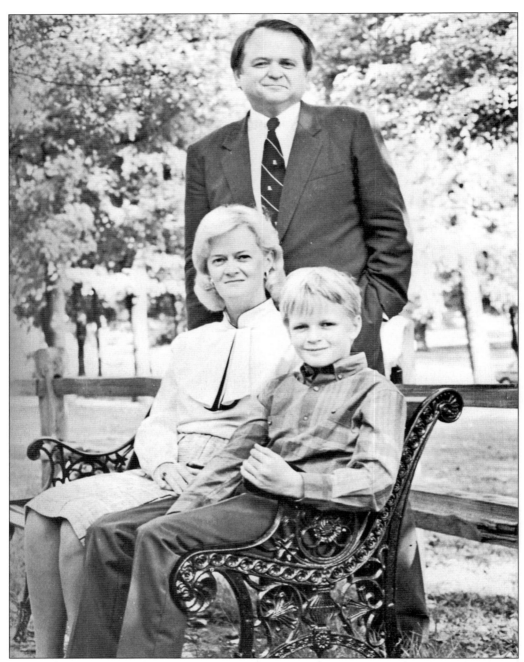

On June 2, 1987, Dr. Thomas F. Boyd was appointed president of Lambuth. His inauguration was October 10, 1987. Dr. Boyd received a bachelor's degree from Union University, holds an M.A.C.T., and received his Ph.D. from the University of Tennessee. During Dr. Boyd's tenure, Lambuth attained university status, enrollment increased, several sports were added to the athletic program, the senior commons was built, Pope Commons was dedicated, a new micro-computer lab was installed for instructional purposes, and the study abroad program was expanded. Dr. Boyd is shown with his wife, Mary, and son, Chris.

Five

LAMBUTH UNIVERSITY

1991–PRESENT

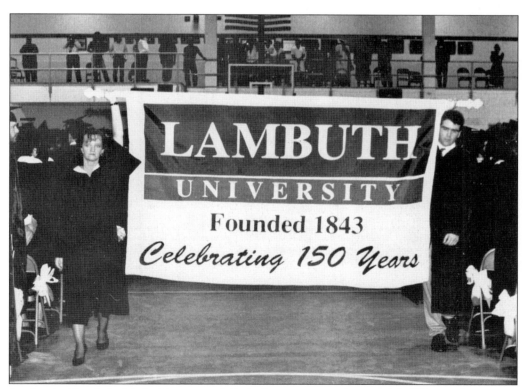

Academic Marshals Marla Eggers and Seth Drown carry the special 150-year banner at commencement in 1993.

The business club was open to students interested in business and provided information on careers and current trends. Dr. Wilburn Lane, advisor, poses with the club for a picture on the steps behind Jones Hall in 1991.

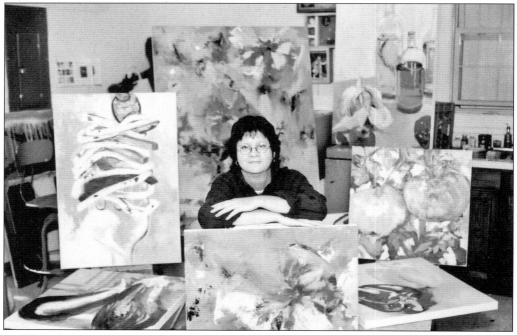

Arts have been a strong program at Lambuth for many years, with regular student exhibits shown. Pictured here is Prof. Lendon Noe with some of her artwork.

There is a family tradition at Lambuth. Some students have parents, grandparents, and great-grandparents who attended Lambuth before them. Here, Jody Pickens (left), a sophomore in 1990, and his brother, Phillip (right), a freshman, follow in the steps of their father, Joe Pickens, who attended and taught at Lambuth.

Work-study provides opportunities for students to earn money on campus, understand how offices work, and gain valuable skills before graduation. In 2000 student workers in the business office join staff for an office party. Shown from left to right are (front row) Judy Payton, Sheila Gillahan, and Jo Ann Daniel; (back row) Gayla Kilzer, Roxann Butler, Norma Wallace, Bud Hoffman, and Eddie Ashmore.

Students and friends are shown together after the International Banquet in 1991. Lambuth enrollment included 43 international students that year.

Study abroad opportunities flourished over the years. In 1996 this group of students studied in Mexico. The group included Christy Shannon, Chris Miller, John Martin, Danya House, Chris Biggs, Jason Cannon, Gerald Bell, Asami Kasumi, Jon York, Ryuichi Otsuki, Greg Grimsley, and sponsor Dr. Becker.

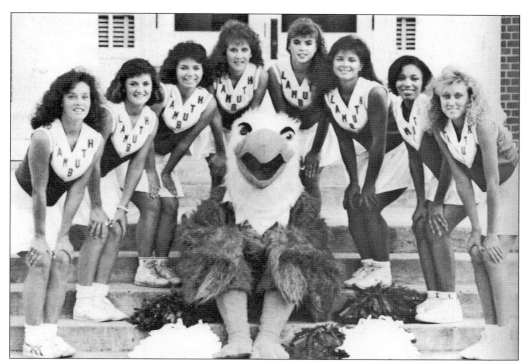

The 1990 cheerleading squad members were, from left to right, Tiffany Pingston, Jackie Smith, April Smith, Vicki Feisal, Bonnie Cunliffe, Kara Majors, Tammy Lee, and Marie Tuttle. They are shown here with mascot LU. The cheerleading squad added men in 1993, which accented their gymnastic performance.

The Eagle soccer team had their first official game in 1992 with a team of 28 players under Coach Mark Johnson. They went to the NAIA play-offs their first year. Lady Eagle soccer started in 1992 with Coach Mark Johnson and assistant coach Claude Locke. Their rigorous schedule included 3 home games and 12 away games.

In 1990 Garen Throneberry won several baseball honors including All-Conference, All-District, and Honorable Mention All-America. Shown are players in 1993.

The Eagles softball team started their first season in 1992 with high spirits. Members from left to right were (front row) Coach Larry Eddings, Melanie Gunn, Heather Melton, Elizabeth Stevens, Denise McDivitt, Erinn McCown, Danya Howse, and assistant Mark Dunn; (middle row) Manager Lauren McAlexander, Dana Warren, Leslie Maddox, Melanie Bowman, Melissa Faust, Elesha Johnson, Stacey Ward, Jennifer Blackwell, and Holly Terrett; (back row) Lisa Deitrich, April Lemons, Carrie Max, Kristen Skinner, Julie Cottham, and Jennifer Wilson.

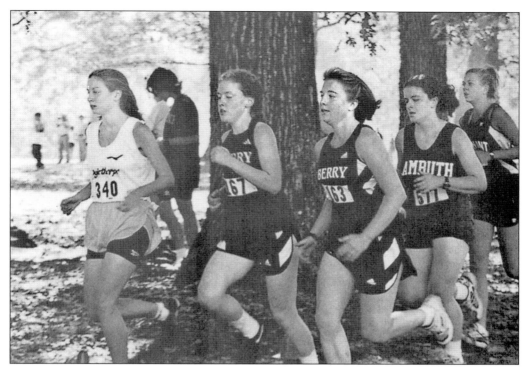

The 1998 cross country team consisted of mostly new runners, but spirits were high. Greg Alter was the first runner in Lambuth history to advance to the NAIA national meet.

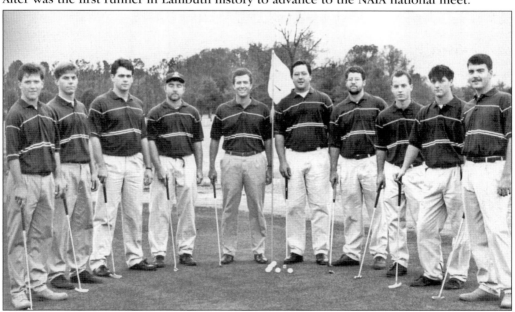

Begun as an intramural sport in 1947, the Lambuth golf team re-emerged in 1992 under the leadership of Joey Heckman, golf pro at Highland Green. In 1994 members, from left to right, were Tommy Gene, Robert Hoen, Brandon Pipkin, Joey Sanders, Chris Culver, Dale Perritt, Paul Hessing, Trip Walker, and Chad Tidwell.

Omicron Phi Tau, an honorary society for students and faculty, focused on current events in 1994. Members from left to right were (front row) Angela Hughes, Marla Eggers, Jennifer Sadler, Bettye Butler, Mrs. Linda Hayes (advisor), and Mrs. Patty Smith; (middle row) Dr. Joy Austin, Kevin Walkup, Jennifer Crews, Ms. Ann Phillips, Mrs. June Creasy, Dr. Ken Wilkerson, and John Garland; (back row) Dr. Charles Mayo, Seth Drown, Dr. Gene Davenport, Allen Curtis, Dr. Brady Whitehead, and Dr. Wilburn Lane.

The 1991 Honors Convocation recognized Susan Hudacek as the outstanding educator, Angie Doyle with the Golden Beck Award, and students for outstanding scholarship and leadership. Recognized students included Brown, Handerson, Byrd, Sturm, Kennedy, Johnson, Dyer, Tippett, Hassell, Oliver, Cleek, Clarke, Miller, Quick, Jones, Hill, Berry, Jackson, Bailey, Moore, McIntyre, Smith, Eggers, Montgomery, Clark, Espey, Himes, and Collins.

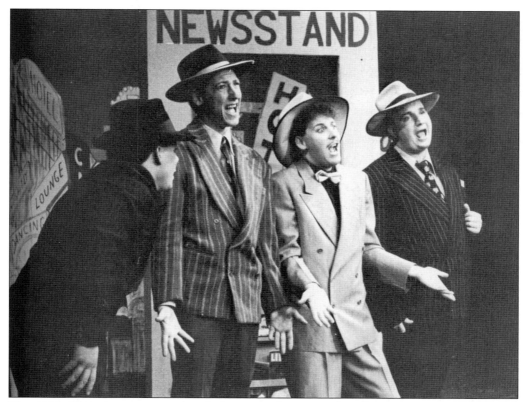

The 1989–1990 theatre opened with the musical *Guys and Dolls*. Main cast members were Jack Seabury, Bob Brown, Jamie Boyd, and Christie Garrett.

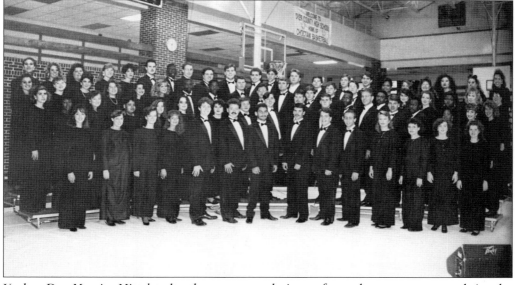

Under Dr. Marcie Mittelstadt, the concert choir performed on campus and in the community. Special performances were given at commencement and at the end of fall and spring semesters.

Kaleidoscope, under the direction of Dr. Marcie Mittelstadt, presented "A Dickens Christmas" in December 1991. Dr. Larry Ray and others transformed the Wilder Student Union into a 19th-century dining hall. The celebration included traditional Christmas dinner, carols, readings, a tree, and, of course, musical presentation.

Phi Mu Sorority was the youngest Greek organization for women on campus in 1982 and won the award for the "Most Outstanding Phi Mu Chapter" in the nation. Shown here are "Les Soeurs Fideles," Phi Mu for Women in 1991.

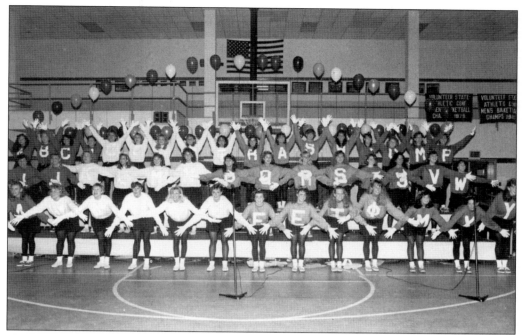

The Greek All-Sing, sponsored by the Inter-fraternal and Panhellenic councils, raises money for the Center for Adult Reading and Enrichment (CARE). Phi Mu presented tunes from *Sesame Street* in 1993.

The women of Alpha Gamma Delta pose at their spring formal, "Petals and Pearls," in 2000.

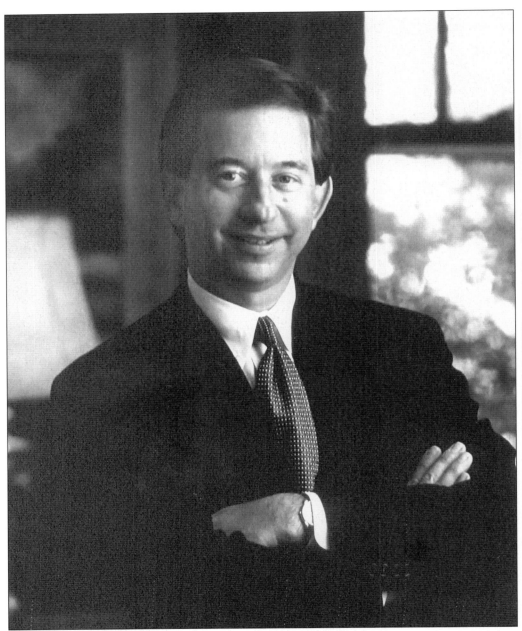

W. Ellis Arnold III was elected by the Lambuth Board of Trustees on November 15, 1996, as president of Lambuth University. He came to Lambuth from Hendrix College, where he served as vice president for Development and College Relations and General Counsel. Prior to Hendrix College, he was in private law practice in Little Rock, Arkansas. During his tenure, the university's long-range plan (Lambuth Vision 2010) was established, full-time faculty increased by over 10 percent, service opportunities increased for students, alumni support increased to record levels, the university's landmark building was dedicated, the theater was renovated, and technological advancements were implemented throughout the campus, including the development of three student computer labs and one teaching lab.

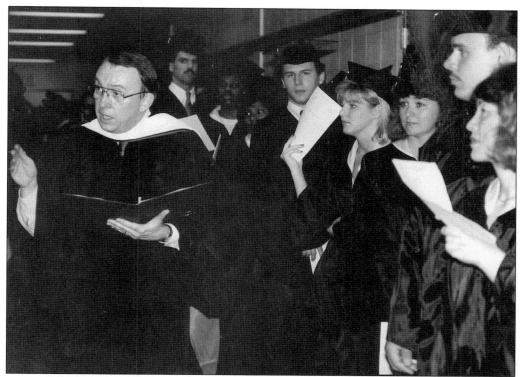

Dr. Don Huneycutt, registrar, gives last-minute instructions to graduates in May 1991.

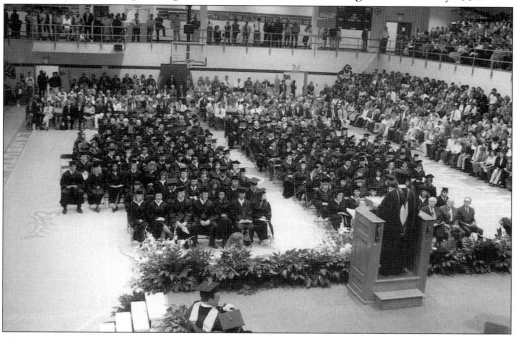

The 1997 commencement services were held in the Athletic Center. President Ellis Arnold prepares to confer degrees.

Lambuth has sponsored a student affiliate chapter of the American Chemical Society since 1965. Field trips for 1996–1997 included Buckman Labs in Memphis and Delta Faucet in Jackson. Officers that year were Marcus Yarbrough (president) and Bridgette Ford (secretary).

The psychology club began in 1996 with the goal of assisting majors with career options and serving the community through projects such as Operation Snack Food. The members in 1997 were, from left to right, as follows: Resie Liberto, Chrystal Wharton, Amy Rust, Brandy Murchison, Anthony Mathenia, Ashlee Bartels, Krista Shoemaker, Natalie Wilson, Christy Grady, Marcelo Psungo, and Dr. Bowers (sponsor).

The political science club, Civitas, learned through experience in and outside the classroom. Members participated in the Model UN, which allowed students to better understand the issues of various nations and dynamics on the world stage.

The Student Government Association serves student interests through sponsoring activities, serving on campus committees, and hearing appeals. The 1992–1993 members were Jason Kent, Fran French, Jim Murphy, Elesha Johnson, Jennifer Sampson, DeMorris Williams, Scott Heinz, Cornelius Mitchell, Leslie Davis, Lori Trew, Amy Rice, Michelle Dally, Valerie Buttrey, Cathy Smith, Penny Wever, Jess Easley, Meg Forsyth, Julie Meadows, Laura Brooks, Melanie Bowman, Jennifer Baker, Lasonda Cherry, Laurinda Drown, Joey Hassell, and Carlie Patron.

Alpha Gamma Delta (Theta Pi chapter), chartered in 1996, sponsored a Sadie Hawkins dance and raised money for juvenile diabetes. Members in 1998 were, from left to right, (front row) Ashlee Bartels, Courtney Nelson, Carolyn Taylor, Ashley Belew, Elizabeth Bridges, Tricia Lowery, Emily Brown, Maggie Middleton, Laura Paley, Theresa Poag, and Mandy Mobley; (back row) Michelle Parks, Jenny Vaughn, Kim Brown, Stephanie Stewart, Deana Davenport, Beth Carpenter, Stacie Behm, Aubrie Ingold, Katherine Thompson, Julie Beaird, Karen Carpenter, and Keesha Bromley.

The Omicron Omicron chapter of Alpha Kappa Alpha Sorority was chartered on December 11, 1988. It was the first African-American Greek organization to be chartered at Lambuth. Members in 2001, from left to right, were Lynn Kirby, Nikeisha Smothers, Lynn Bowie, Erica Thomas, and Tanshanieka Perry.

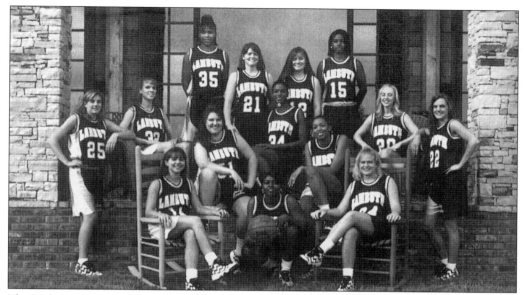

The Lady Eagles met the challenge of competing in the new Mid-South Conference in 1996. Team members from left to right were (front row) Melinda Gray (seated), Temika Boga (kneeling), and Allison Carter (seated); (middle row) Kari Pruehsner, Brooke Fry, Amanda Smith, Latoya Lake, Becky Brewer, unidentified, and Angie Williams; (back row) Tawanna Taylor, Julie Jackson, Kristi Lott, and Kyonlia Jones.

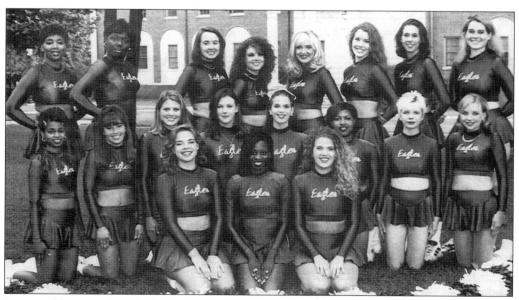

A new addition to Lambuth sports was the women's dance team in 1994. The 20-member squad performed at basketball and football games and participated in intercollegiate competition under the direction of dance instructor Vickie Dennison.

Basketball games were a highlight of the winter months for students and other Eagles fans. As part of the Athletic Center, the gym was home to ballgames, entertainment events, classes, and other Lambuth events.

Campus involvement is an important part of a Lambuth experience. Here students from various Greek and social organizations pose for a shot in front of the flagpole and chapel.

Service is of great importance at Lambuth. Students have participated in building projects on campus and service in the community, including tornado relief and Habitat for Humanity. Here they are shown building the shelter house on the back side of campus.

The Fellowship of Christian Athletes was the largest religious life group on campus and was open to all students. Members in 1998 were students Brown, Limbaugh, Belvin, Allen, Vawter, Pemberton, Meals, Kelley, Bennett, Jamison, Jacobs, English, Darty, Whiteside, Davidson, Scott, Ward, Lindsey, McClarin, Stilwell, Pence (advisor), Hanna, Hope, Jordan, Lipscomb, Maddox, McDonald, Middleton, Moore, Paley, Paulsmeyer, Poag, Powell, Rockenstock, Silcox, and Woods.

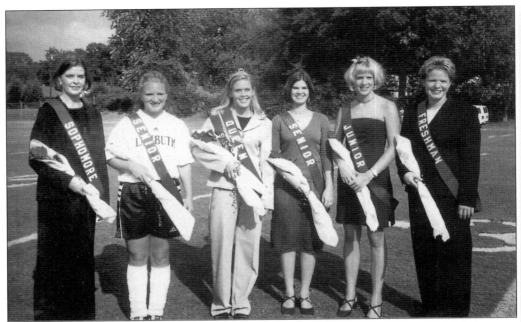

The 1999 homecoming court is honored during halftime of the football game on L.L. Fonville Field. Shown here are, from left to right, Amy Murphy, Heather Hite, (Queen) Heather McCormick, Jenny Vaughn, Heather Welker, and Sarah Shaddick.

Oxley Square, completed in 1995, is an apartment-style complex that serves as a residence for upperclass men and women selected on the basis of scholarship and leadership. Named for Dr. Arthur Daniel Oxley, the four residence halls located within the Oxley Square (Whetstone House, Henley House, Dawson House, and Loeb House) were dedicated in December 2000.

The senior breakfast is a traditional part of commencement weekend each year, sponsored by the faculty social committee. Wisdom Parlor is transformed into an English tearoom for the event.

Students relax at Johnny Rockets on a day away from school. Shown from left to right are Holly Belvin, Dana Skelley, Brandon Dyce, Natalie Wilson, Heather Hite, Lisa Clark, and Danny Rhodes.

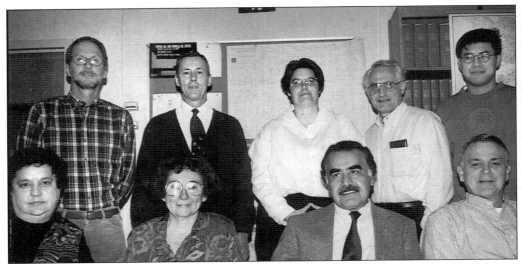

The School of Natural and Applied Sciences 1996–1997 faculty members were, from left to right, (front row) Sandra Givens, Jo Booth, Yadollah Kamy Kazempour, and Charles Bray; (back row) David Hawkes, William Davis, Vicki Moeller, Ronnie Barnes, and Ming Jin. Lois Lord and Jerry Peters are not pictured.

The School of Arts and Communication 1996–1997 faculty members were Rosemary Caraway, Patty Smith, Lendon Noe, Gary Drum, June Creasy, Florence Dyer, Jo Fleming, Larry Ray, and Dick Brown. Dalton Eddleton is not pictured.

The School of Humanities 1996–1997 faculty members, from left to right, were Joy Austin, Susan Hudacek, Robin Rash, Brady Whitehead, Kenneth Wilkerson, Ann Ecoff, Charles Mayo, Eileen Hinders, Gene Davenport, and Alan Asnen.

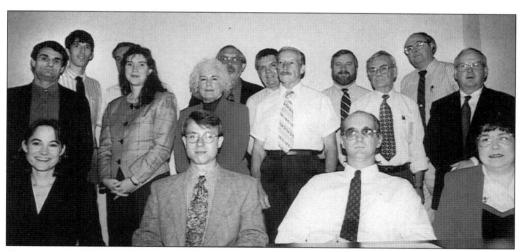

The School of Business and Professional Studies 1996–1997 faculty members were Cheryl Bowers, Chris Manner, Ronald Becker, Mary Roby, Paul Jacobson, Jenny Douglas-Sevier, Emmy Lou Whitehead, Robert Mathis, Delbert Hurst, Wilburn Lane, Randall Austin, Jerry Peters, Gary Boutwell, Samuel Faught, Frank Markham, and David Sargeant. Not pictured is Dianne Schnell.

The student ambassadors reach out to prospective students and their families to promote Lambuth and assist with student recruitment. The 2001–2002 ambassadors were students Adkisson, Banks, Birdsong, Brown, Buitenwert, Canada, Clark, Coker, Dzopalic, Edwards, Essex, Fox, Freese, Freytag, Gebhart, Graves, Gray, Guffey, Haynes, Highfield, Holloway, Irwin, Lee, Lyons, Nikolas, Orr, Phillips, Sayroo, Tate, Thompson, Tyler, Wheeler, and Williams.

The Inter-fraternal Council in 2001–2002 worked to coordinate fraternity activities across campus. Members were Eric Bradshaw, Ryan Watson, Rob Dunbar, Josh Roberts, Heath Morgan, Brian Moore, Jeremy Whitten, Trey McClarnon, Daniel Irwin, Clay Crockett, Josh Shearon, Joe Martini, and Brian Bridgman.

Phi Sigma Eta is a Christian sorority that was started in 1995 to focus on spiritual growth. In 1999 members were, from left to right, (first row) Jamison, Shepherd, Christian, and Sears; (second row) Middleton, Jordan, Roberts, Limbaugh, Smith, and Beaird; (third row) Hathcock, Lemasters, Crawford, Simpson, Eubanks, Wilson, and Max; (fourth row) English, Wimpee, Phelps, Lee, Brockman, Baute, Melton, and Slover. Alpha Omega, chartered on October 3, 2000, was the male Christian service organization.

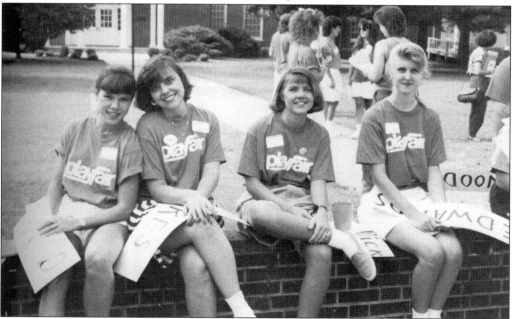

Peer advisors play an important role in orienting new freshmen each fall during orientation and freshman seminar. Peer advisors Janna, Renee, Kelli, and Jimmie rest between activities in August 1989.

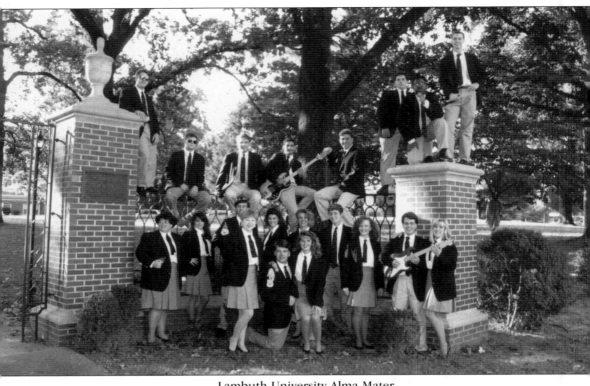

Lambuth University Alma Mater

Lambuth to thee belongs our loyalty
And thus in song we lift our voices unto thee
Our alma mater ever be.
As we come with dreams of youth, let us leave with purest truth.
Raise the lamp, the white and blue
For whatsoever things are true,
Whatsoever things are true.

–Richard and Cynthia Brown, 1986